A Celebration of
Pennsylvania's
Covered Bridges

Michael P. Gadomski

SCHIFFER
PUBLISHING

4880 Lower Valley Road · Atglen, PA 19310

Other Schiffer Books by the Author:
Reserves of Strength: Pennsylvania's Natural Landscape
978-0-7643-4422-0

Pittsburgh: A Renaissance City, 978-0-7643-4923-2

The Poconos: Pennsylvania's Mountain Treasure,
978-0-7643-4924-9

Philadelphia: Portrait of a City, 978-0-7643-5108-2

Published by Schiffer Publishing, Ltd.
4880 Lower Valley Road
Atglen, PA 19310
Phone: (610) 593-1777; Fax: (610) 593-2002
E-mail: Info@schifferbooks.com
Web: www.schifferbooks.com

Library of Congress Control Number: 2022946126
Cover design by Danielle Farmer
Type set in Superclarendon
ISBN: 978-0-7643-6824-0
Printed in China

"Schiffer," "Schiffer Publishing, Ltd. & Design," and the
"Design of pen and inkwell" are registered trademarks of
Schiffer Publishing, Ltd.

For our complete selection of fine books on this and related
subjects, please visit our website at www.schifferbooks.com.
You may also write for a free catalog.

Schiffer Publishing's titles are available at special discounts
for bulk purchases for sales promotions or premiums. Special
editions, including personalized covers, corporate imprints,
and excerpts can be created in large quantities for special
needs. For more information, contact the publisher.

We are always looking for people to write books on new and
related subjects. If you have an idea for a book, please
contact us at proposals@schifferbooks.com.

*[cover] According to Bedford County Visitors
Bureau, the current refurbished 91-foot-
long, Burr truss, Hall's Mill Covered Bridge
spanning Yellow Creek was built in 1884. It is
the seventh bridge built on this location since
1860. It was listed on the National Register of
Historic Places in 1980*

*The Stoner/Bowmansdale Covered
Bridge spans Yellow Breeches Creek
in Cumberland and York Counties at
Messiah College. The original bridge
was built in 1867. It was rebuilt in
1972 by the students of the college
but is no longer officially considered
an authentic historic structure due
to extensive reconstruction.*

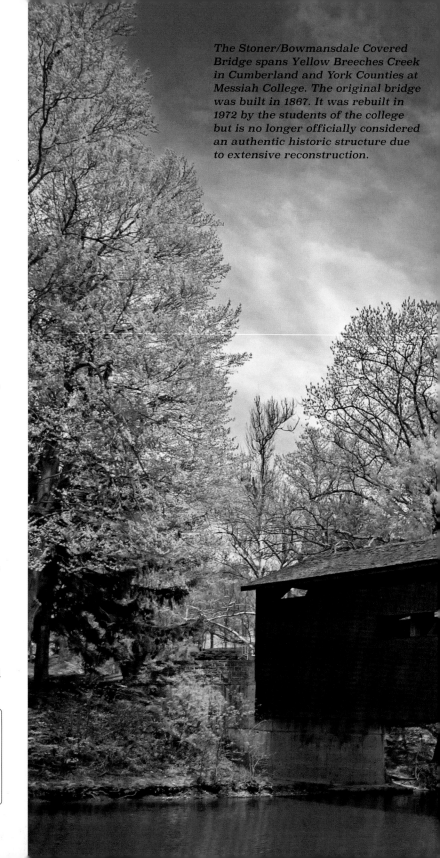

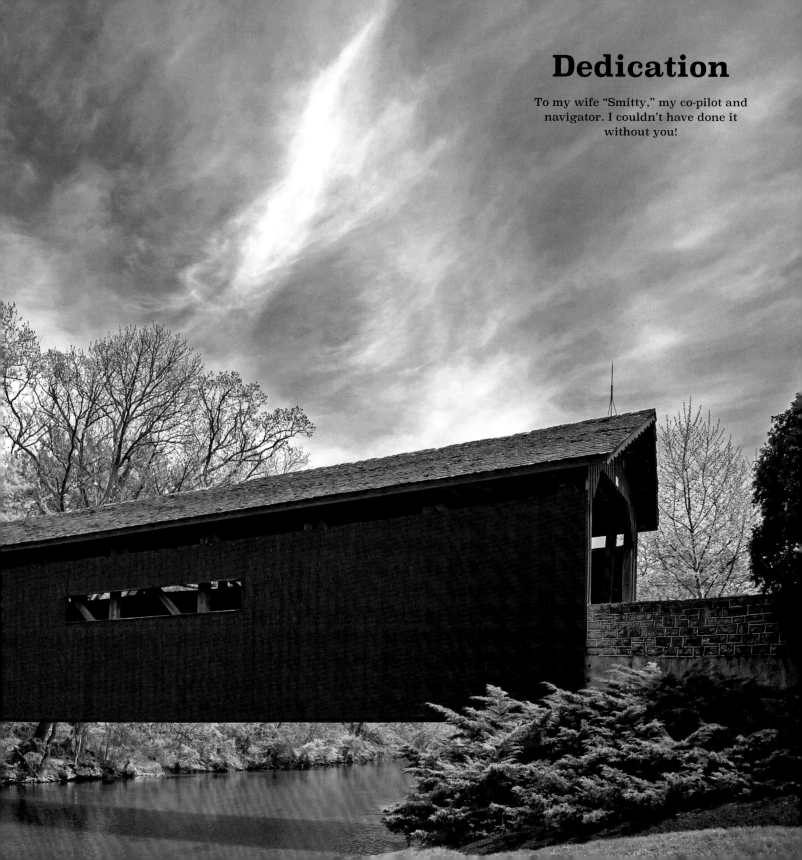

Dedication

To my wife "Smitty," my co-pilot and navigator. I couldn't have done it without you!

Introduction

There was a time when America was rural. It was a time when more people lived in the country than in cities. We lived on farms, ranches, lumber camps, and tiny villages, which served as the centers of local commerce, government, and social life. We lived close to the land, and the land provided most of our livelihood. It was a time when we produced more things than we manufactured, and what we did manufacture was usually for our own use to help us produce. We produced agricultural products: some for export, some for local sales, but mostly for ourselves and families. We produced lumber, some ore, and charcoal to smelt the ore. We harvested fish, game, ice, and wild fruits and nuts. We knew the names and uses of the wild plants that grew around us. There were no apps to identify the plants and animals; rather, this knowledge was handed down from generation to generation. We were independent, self-reliant, and resilient.

It was a time when you could tell the occupation of a stranger just by shaking their hand, since the farmer, logger, teamster, blacksmith, and commercial fisherman all had a different grip developed through years of toil in their given trade.

Our idea of social media consisted of a chance meeting at a general store, after Sunday services, or at town meetings. We knew our neighbors and valued our friendships. And even though we might have often lived in relative isolation from our neighbors, we considered ourselves a community. "Unfriending" our neighbor was generally not in our best self-interest, since someday we might need that neighbor's help, or he might need ours.

It was a time when a "farm to table"

dinner was a daily event, not an inflated, high-priced social event where the importance of being seen is greater than that of what is on the table.

Before the Industrial Revolution, cities were a place for commerce and trade. It was the rural areas where the real production in the nation occurred. We made nearly everything from wood. We knew what kind of wood had the best use for what, and we found a use for every kind of wood. There are around 278 species of trees and shrubs native to Pennsylvania, more than all of Europe, and we knew all our local species and their uses like we knew old friends. Wood was abundant in early American Pennsylvania, since the commercial "Great Clear-Cut" of the later nineteenth and early twentieth centuries had not yet occurred. The forests were vast and seemingly inexhaustible. And we built our bridges with wood.

The Pennsylvania Department of Transportation estimates that at the height of covered-bridge construction, Pennsylvania had around 1,500 covered bridges. At one time, sixty-four of Pennsylvania's sixty-seven counties had covered bridges. Today there are a little over two hundred left, with one or two lost to fire or flood every few years. But there are still more covered bridges in Pennsylvania than in any other state. Pennsylvania's covered bridges represent about a fourth of all covered bridges in the United States today, making Pennsylvania the true "covered-bridge capital."

Although forms of covered bridges go back to about 550 BCE in Babylon and again during the Middle Ages in Europe, these were mostly pedestrian bridges, not meant for heavy traffic, often no longer than a single span of timber. It was not until the modern

American invention, in the late eighteenth and early nineteenth centuries, of the modern truss-type bridges, which allowed for greater lengths and heavier traffic, that we saw the start of covered-bridge construction and, later, modern steel-bridge construction.

George Wilson Peale, who is better known for his portrait of George Washington, received the first US patent for a wooden covered bridge in 1797. Although Peale never actually built a covered bridge, he did suggest the site on which Timothy Palmer built the first American covered bridge in 1804 over the Schuylkill River in Philadelphia. The bridge was said to be 550 feet long and covered three spans, with two lanes for traffic and a pedestrian walkway on each side.

Also, in 1804 Theodore Burr invented an arched truss, which made for a significant advancement in bridge strength design. He received his first patent, which later became known as the "Burr truss," in 1806. The Burr truss is the mostly commonly used truss in Pennsylvania's covered bridges. Soon other patents were awarded to bridge builders for their unique truss designs: Ithiel Town (Town truss) in 1820, William Howe (Howe truss) in 1840, Robert W. Smith (Smith truss) in 1869, and several others. Simply put, a truss is defined as an "assembly of members such as beams, connected by nodes, that creates a rigid structure."

People often ask, "Why cover a bridge?" Some might guess that it's to keep snow off the road surface. But actually, prior to the automobile, snow was desired on road surfaces, since horse-drawn sledges were often the only means of transportation in winter. All heavy hauling occurred in

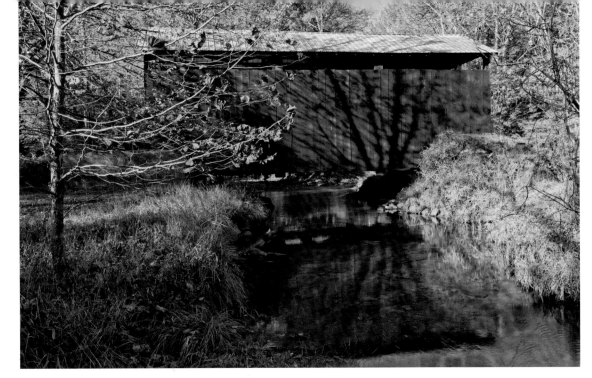

Constructed in 1881 near the former Iram Derr's sawmill, the Creasyville Covered Bridge in Columbia County spans Little Fishing Creek in a remote scenic area of the county. It was built at a cost of $301.25 and was probably first known as Derr Bridge.

winter over snow and ice. Snow- and ice-covered roads back then were a necessity and a blessing, not an inconvenience as they are today. Some areas hired "snow wardens," whose responsibility was to cover bare spots on the roadway with snow, especially covered bridges, so sleds could easily pass. The work was called "to snow the bridge." Other areas had a "bridge-man / toll keeper" whose job, besides covering the bridge road surface with snow, was to collect a toll from the bridge users.

Others guessed that a covered bridge gave a sense of security to the animals crossing the bridge, so they would not see the water and would think they might be going into a barn. Actually, the animals were used to fording smaller streams where bridges were not necessary. And some might have even enjoyed a drink from the creek on a warm summer's day.

The actual reason for a covered bridge was to cover and protect the truss system from the weather and elements. Although wood is a practical and outstanding building material for a bridge, it is nevertheless organic and subject to decay. The truss system was the costliest part of the bridge's construction, and it provided the strength and safety of the bridge. It has been estimated that with a cover-ing over the truss, a bridge's life could be extended sevenfold.

Most people would probably define a covered bridge as one that has an overhead roof. However, the *World Guide to Covered Bridges* defines a covered bridge as one that has its truss covered, and an overhead roof is not necessary. A bridge with a cov-ered truss and no overhead roof is called a "boxed pony bridge." An excellent example of a boxed pony bridge, and the only one of its kind in Pennsylvania, can be found at Ralph Stover State Park in Bucks County. It is sometimes referred to as the Mean's Ford Bridge.

Although today we look upon covered bridges as beautiful elements of a rural landscape, in their day they were an important part of the local economy. They connected farms to villages and mills. Often, businessmen would form a company and sell shares to have a bridge built. Requests for bids were sent out to bridge builders, and to recover the costs, tolls were charged for a bridge crossing. There were set tolls for each man, horse, ox, carriage, wagon, wheelbarrow, and even circus parades.

The bridge took on the names of a nearby town, mill, farmer, or bridge builder. Over time, some of these bridge names changed yet, at the same time, retained their former name. That is why today several bridges have two or three official names.

Like many wooden barns of their time, covered bridges were often painted red. The reason was simple: red paint was cheap. The paint was homemade and usually consisted of only three ingredients: skimmed milk, lime, and rust (iron oxide). If linseed oil was available, it was sometimes

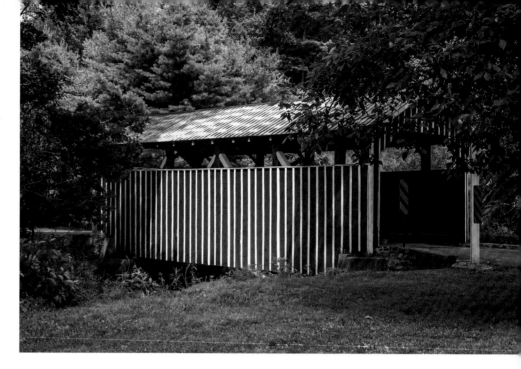

The unique Hummel's Church / Rebuck Covered Bridge in Northumberland County is covered with red vertical boards and white battens. Built in 1874, the 43-foot-long bridge spans Schwaben Creek near the site of the nineteenth-century Schwaben Creek Werewolf folk legend.

added. This simple paint was enough to protect the wood and make the bridge attractive.

Much like the "Mail Pouch Tobacco" barns that many people are familiar with, covered bridges sometimes had advertisements painted on their sides. Not only Mail Pouch Tobacco, but all sorts of products and services, from Coca-Cola to the local blacksmith shop or undertaker. These advertisements were among our first highway billboards and, along with tolls, contributed to the bridges' profit and helped with the cost of construction and maintenance. The interior of the bridges often had painted advertising signs on the beams and sidewalls, while handbills were posted throughout the interior, announcing a coming local event or advertising a small local business. Travelers passing through the bridge would often take their time, reading all the advertisements and handbills, especially while enjoying the cooling shade on a hot summer's day or sheltering from a storm outside.

With their high exposed beams and dark interior, some covered bridges may have been the site of hangings and even lynchings. We may never learn the whole truth and all the facts, because frequently people did not speak afterward about such events. Legends linger about Sauck's Covered Bridge near Gettysburg in Adams County. It is well documented that both Union and Confederate troops used the bridge during the 1863 Battle of Gettysburg during the American Civil War. What is not so clear are the details of the alleged hanging that took place at the bridge. One legend tells of three Confederate deserters who were hanged by their superiors, while another tells of three Confederate spies who were hanged by Union troops. Today, many people claim that the bridge is haunted by the spirits of the men who were supposedly hanged there.

On a different, more romantic note, soon covered bridges became known as "kissin' bridges." It not only was common practice but was expected and

rather appropriate that a young man would steal a kiss from the young woman by his side, in the horse-drawn carriage or sled, as they passed through a covered bridge. If younger brothers and sisters knew in advance that their older siblings would be passing through the bridge, they would climb and hide in the rafters, trying not to giggle when the kiss was stolen. In a way, this tradition continues today, especially on the pedestrian-only bridges: and not just stolen kisses, but also marriage proposals and even weddings. Many portrait photographers use covered bridges as a background or setting for engagement or wedding photos, often at the couple's request.

So, when visiting a covered bridge, do not look at it as some simple, quaint curio or as a novelty from the past. They are more than that—much more! They each have a story of their own to tell, and collectively they tell an even larger story. They tell the story of who we were and how we lived only a few generations ago. It's a story that is

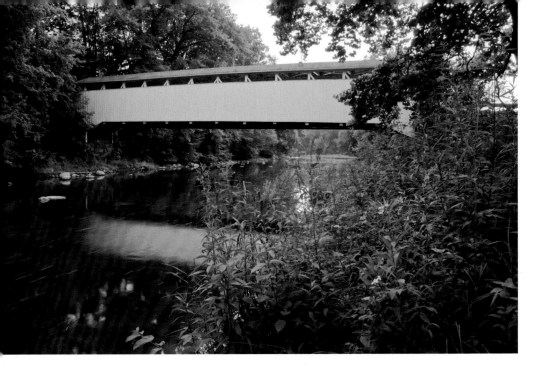

The 121-foot-long Banks Covered Bridge in Lawrence County was built in 1889 over Neshannock Creek, a famous fly-fishing trout stream. To handle modern traffic, it has been reinforced with steel girders under the deck of its historic wooden Burr arch truss.

fading rapidly in our fast-paced world of the internet, mass media, and marketing. It's a story of hard work, self-reliance, and living close to the land. It's a story of craftsmanship and handmade quality. Touch the hand-hewn beams and braces, which were cut and shaped with simple tools. Imagine the sweat from the forehead of the builder dripping into the wood. Look closely at the simple wooded pegs that have held the whole frame together so securely for over 150 years, and compare it to how today some of our electronic devices are obsolete and unrepairable after a few short years.

Covered bridges are more than a means to cross a stream or creek. They are bridges to our past, our history, our heritage, and maybe our own individual ancestry. Maybe your great-great-grandfather was crossing through a covered bridge on a spring day and stole a kiss from a young woman who later became your great-great-grandmother—and here you are today. Now wouldn't that be special?

Notes from the Author:

This book does not cover all covered bridges in Pennsylvania. That was never the intent. Rather, it is an overview and celebration of the commonwealth's covered bridges. There are several other publications that cover all the bridges.

The reader might find different dates or measurements in other publications. The information provided by the Pennsylvania Department of Transportation was used as the main source for this book.

Also, this is not a guide on locating these bridges. Other books and websites do that very well already, and any GPS mapping unit will likely guide you to all the bridges in the state.

Every few years, a bridge seems to be destroyed through vandalism. If you should happen to witness anyone damaging these treasures, do not be afraid to report it to the authorities, even if it's just a vehicle license plate number.

Last, when visiting any of the bridges, they may not look exactly the same as photographed in the book. Landscapes are constantly changing from year to year, and from the time the bridges in this book were photographed to the time the book appeared in print, things have changed already.

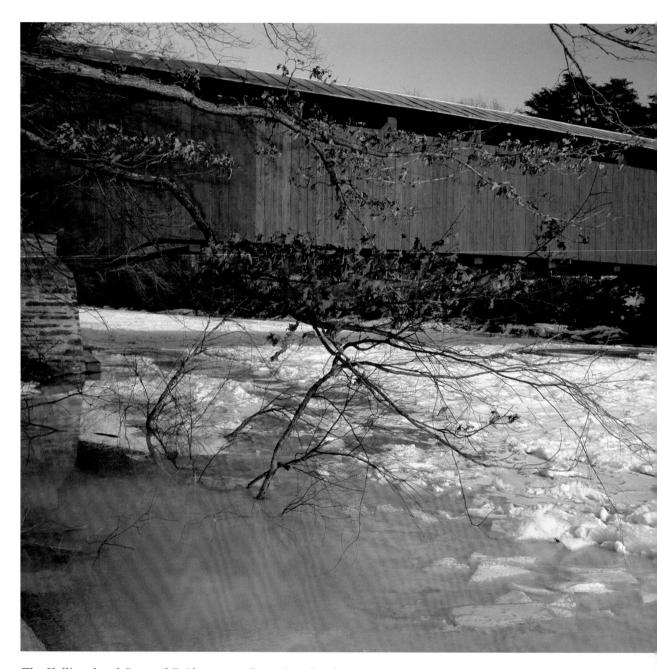

The Hollingshead Covered Bridge spans Catawissa Creek in
Columbia County. The 116-foot-long bridge was built in 1851 at a
cost of $1,180.00 and named for Henry Hollingshead, who owned
a nearby mill. It was added to the National Register of Historic
Places in 1979.

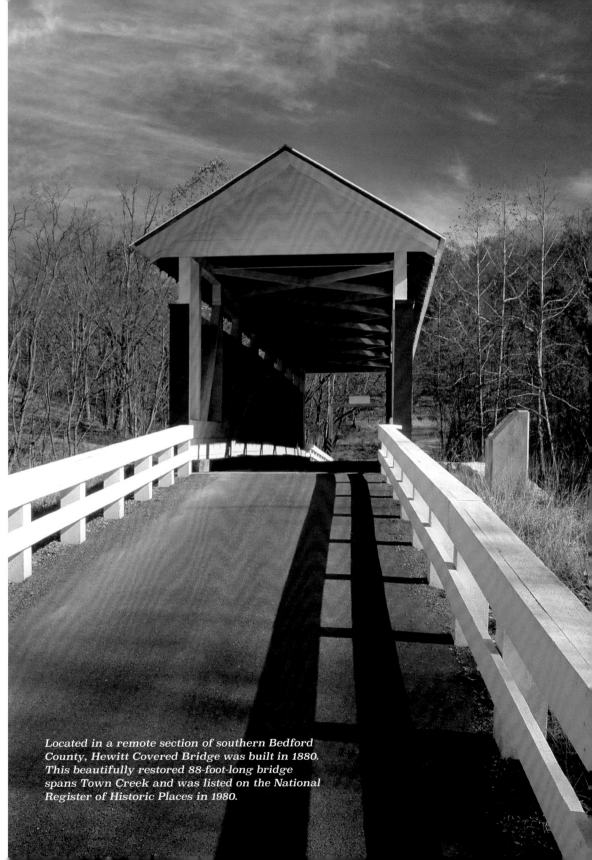

Located in a remote section of southern Bedford County, Hewitt Covered Bridge was built in 1880. This beautifully restored 88-foot-long bridge spans Town Creek and was listed on the National Register of Historic Places in 1980.

Located next to a beautifully restored mill, McConnell's Mill Covered Bridge is preserved in 2,546-acre McConnell's Mill State Park. The 96-foot-long bridge was constructed in 1874 and was listed on the National Register of Historic Places in 1980. It spans the Slippery Rock Creek Gorge, a National Natural Landmark.

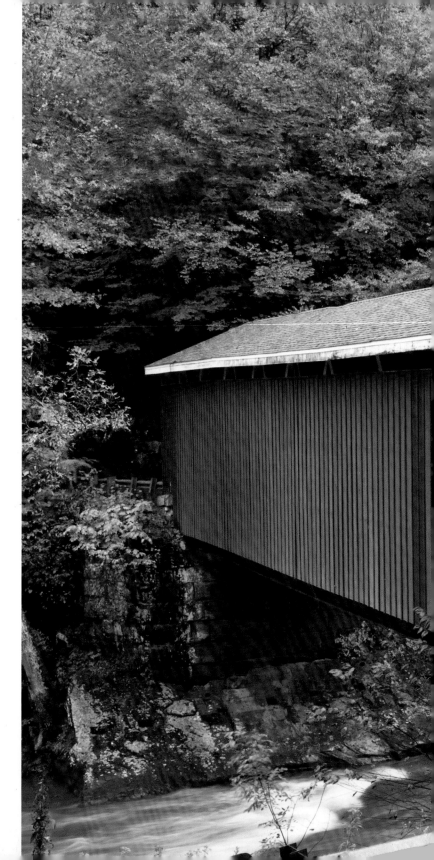

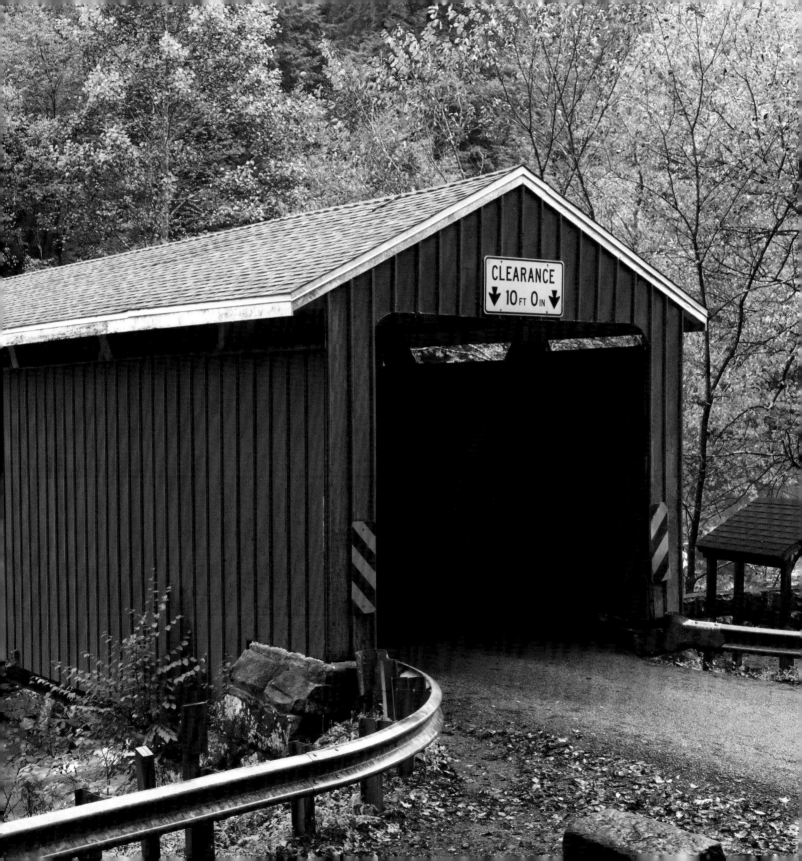

The Bistline / Flickinger's Mill Covered Bridge is located near the scenic borough of Blain, Perry County, in Pennsylvania's Ridge and Valley region. The 96-foot-long bridge, which spans Sherman Creek, was constructed in 1871 and was listed on the National Register of Historic Places in 1980.

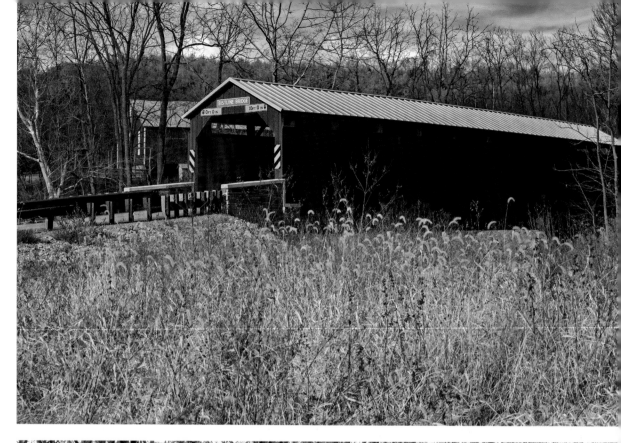

The Clays/Wahneta Covered Bridge was moved 1 mile to its current location when Little Buffalo Creek was dammed to create Holman Lake at Little Buffalo State Park in Perry County. The 82-foot-long bridge, built in 1890, is decorated every year for the park's annual family-oriented Christmas Walk event.

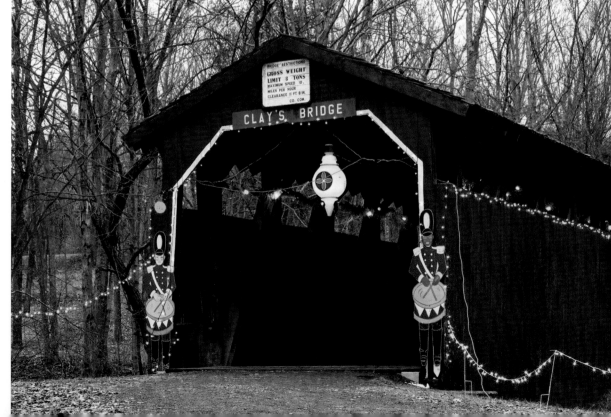

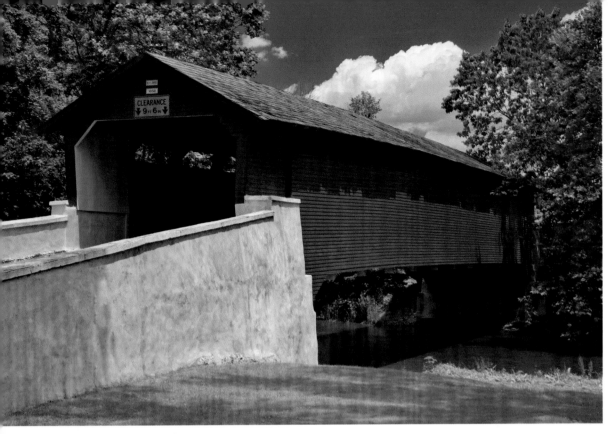

The 116-foot-long Rex's Covered Bridge in Lehigh County was built in 1858 to span Jordan Creek, a tributary of the Lehigh River. It is believed that it was named for the Rex family, local landowners. It was added to the National Register of Historic Places in 1980.

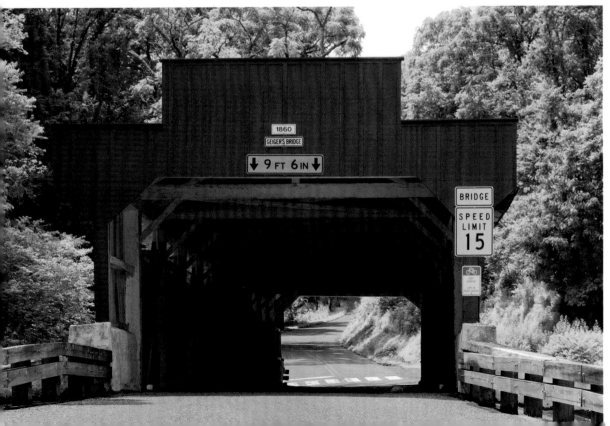

The 112-foot-long Geiger's Covered Bridge in Lehigh County, with the unique stepped portal design, spans Jordan Creek. Built in 1860, it is named for the Jacob Geiger family, who settled in the area after emigrating from Germany in the 1770s. It is located on the Trexler-Lehigh County Game Preserve.

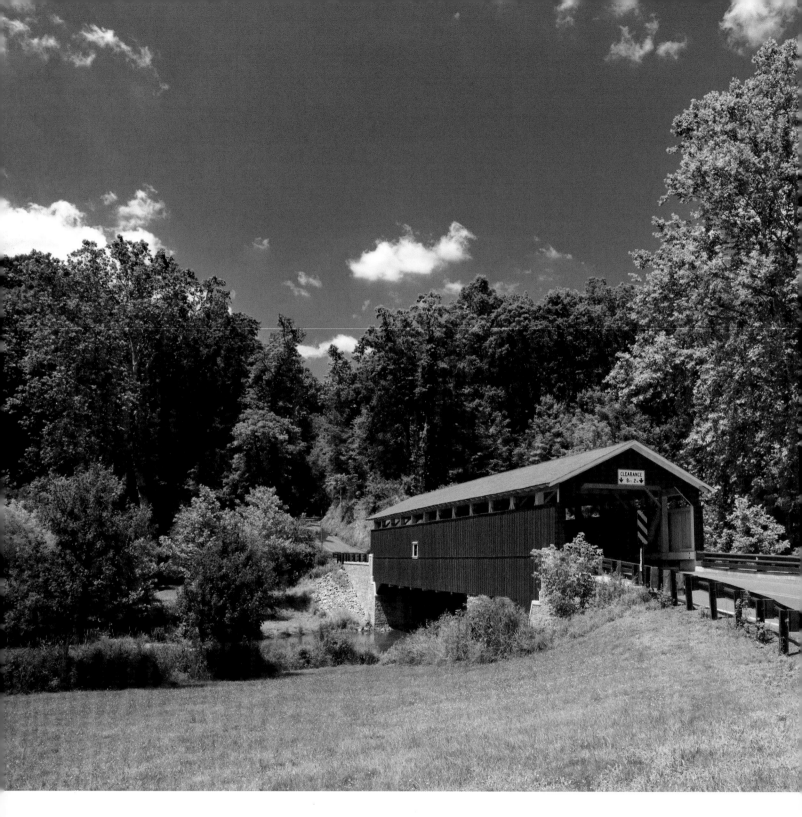

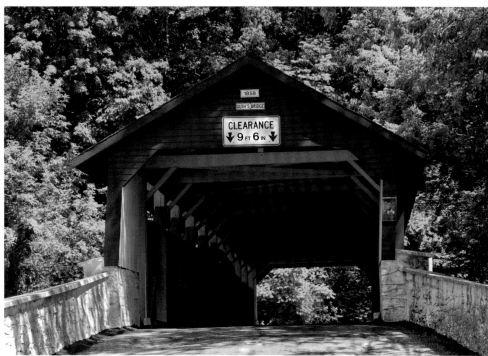

The 108-foot-long Manasses Guth Covered
Bridge in Lehigh County was named for
the descendant of Lorentz Guth, the first
settler in the area in 1745. The original
bridge was partly destroyed by fire in 1858
and rebuilt in 1882. It spans Jordan Creek
at the eastern edge of Covered Bridge Park.

Originally built in 1882, 108-foot-long Schlicher's
Covered Bridge in Lehigh County was closed
to traffic in 2009 due to its declining condition.
In 2014 it was reconstructed at a cost of $1.8
million, preserving 10 percent of its original
materials and allowing it to retain its National
Registration of Historic Places designation.

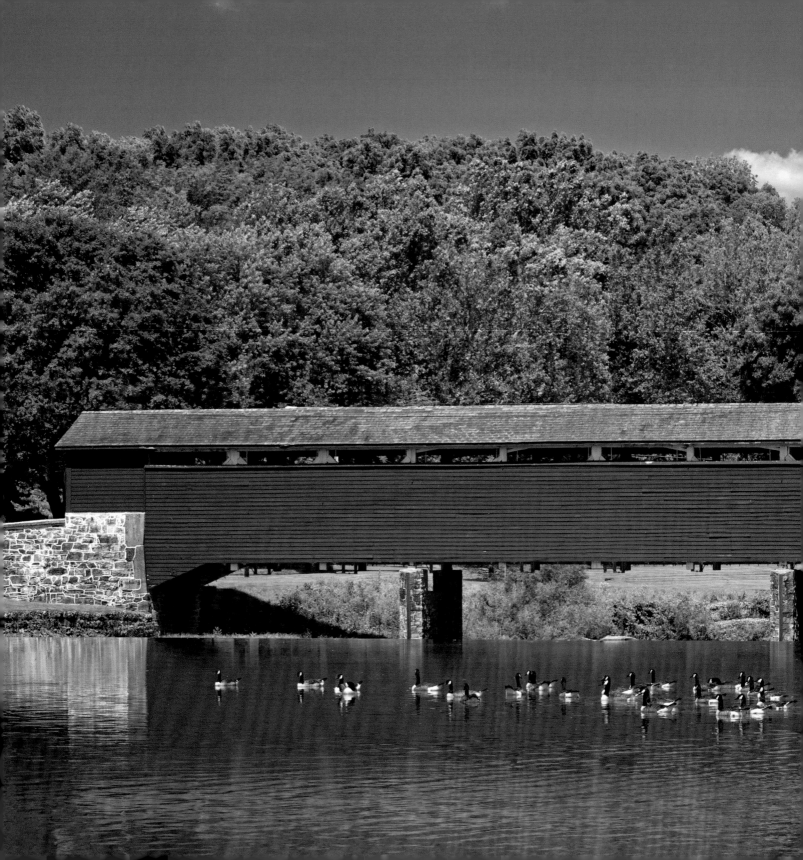

Wehr's Covered Bridge is located in Lehigh County's scenic Covered Bridge Park. Built in 1841, the 117-foot-long bridge spans Jordan Creek. It was originally named Sieger's Covered Bridge after Epharim Sieger, who built a nearby mill in 1862. The mill was torn down in 1951, but the millpond remains.

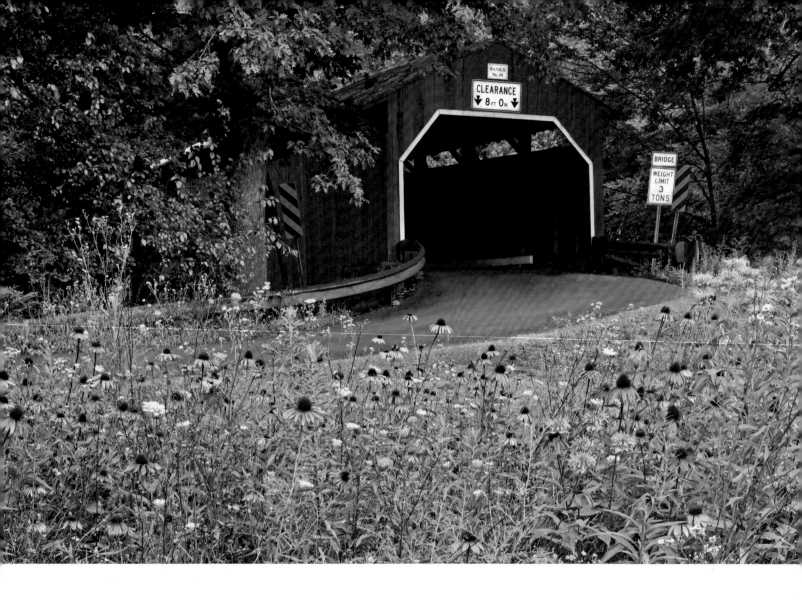

Built in 1844 at a cost of $500.00, Wanich
Covered Bridge in Columbia County
was named after John Wanich, a local
farmer. The 98-foot-long bridge spans
Little Fishing Creek. It was added on the
National Register of Historic Places in
1979. In summer, meadow wildflowers
grace a neighboring field.

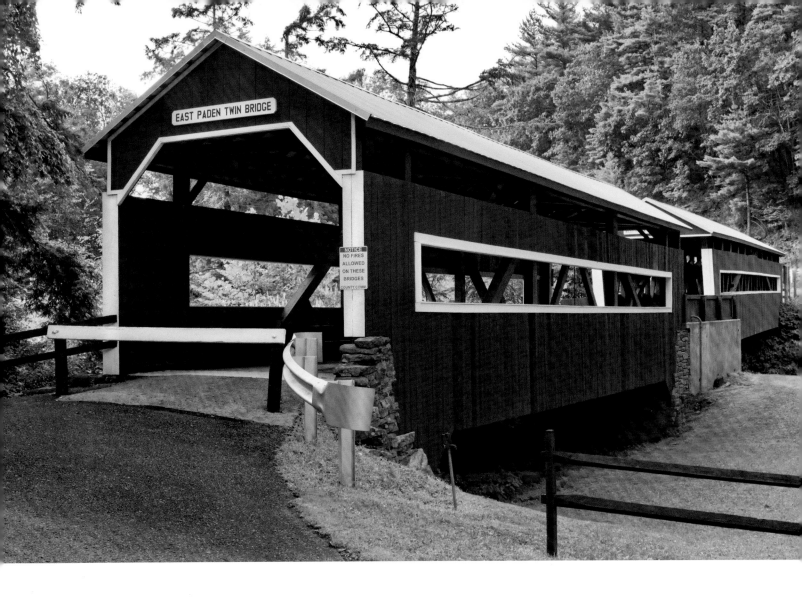

East and West Paden (Twin Bridges)
Covered Bridges in Columbia County
are the only twin bridges in the United
States. Named for John Paden, who owned
a nearby sawmill, the bridges were
originally built in 1850 at a cost $720.00.
Their combined length of 187 feet spans
Huntingdon Creek.

19

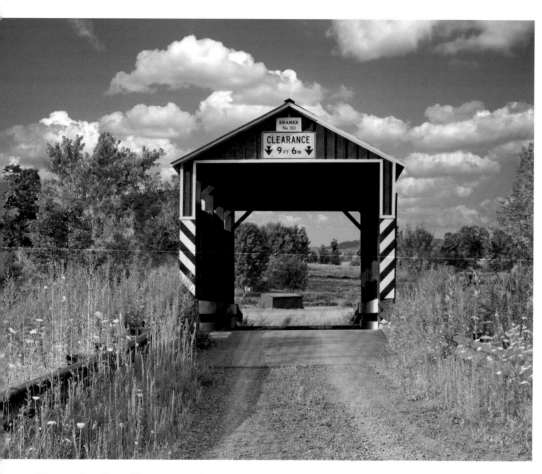

The 50-foot-long Kramer Bridge, which spans Mud Run in Columbia County, dates back to 1881, when it was constructed at a cost of $414.50. It was listed on the National Register of Historic Places in 1979 and refurbished in 2007. The bridge was named for Alexander Kramer, a local farmer.

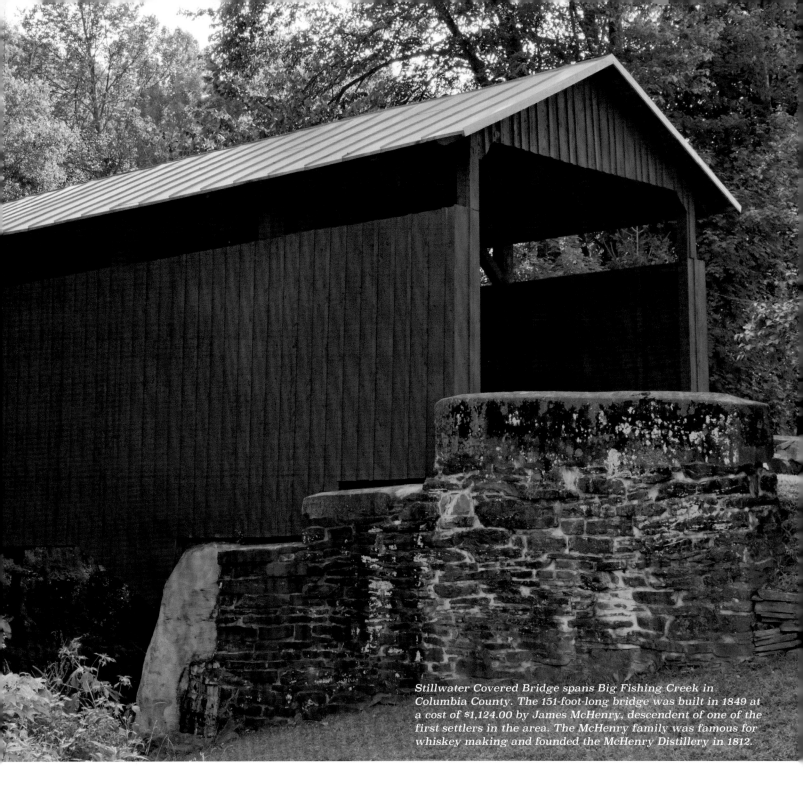

Stillwater Covered Bridge spans Big Fishing Creek in Columbia County. The 151-foot-long bridge was built in 1849 at a cost of $1,124.00 by James McHenry, descendent of one of the first settlers in the area. The McHenry family was famous for whiskey making and founded the McHenry Distillery in 1812.

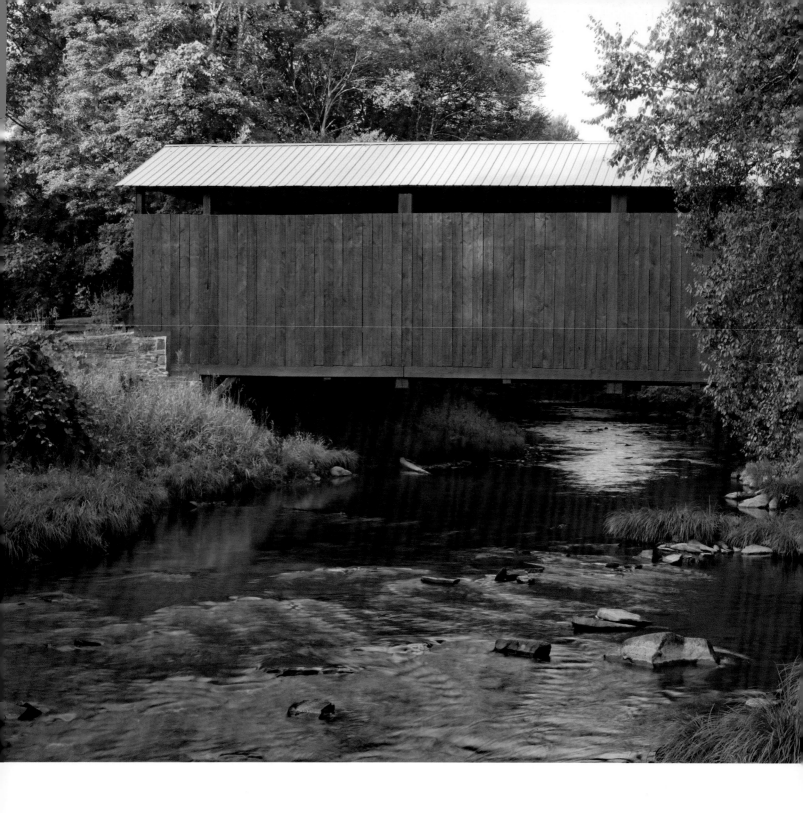

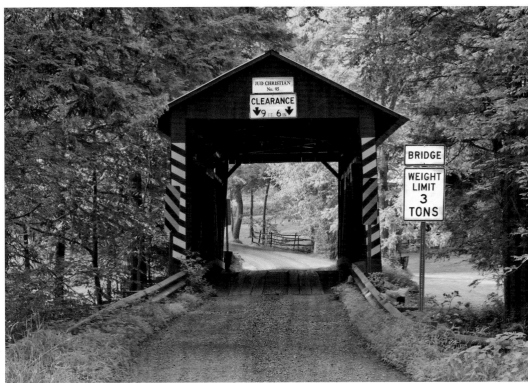

Jud Christian (Christie) Covered Bridge was built in 1876 for $239.00 over Little Fishing Creek in Columbia County. It was named for a local farmer and lumberman, Jud Christian. The 63-foot-long bridge was added to the National Register of Historic Places in 1979.

Sam Eckman Covered Bridge on Little Fishing Creek in Columbia County was named for Samuel Eckman, a prominent farmer and businessman who operated a shingle mill and birch oil factory. The 65-foot-long bridge was built in 1876 for $498.00 and was listed on the National Register of Historic Places in 1979.

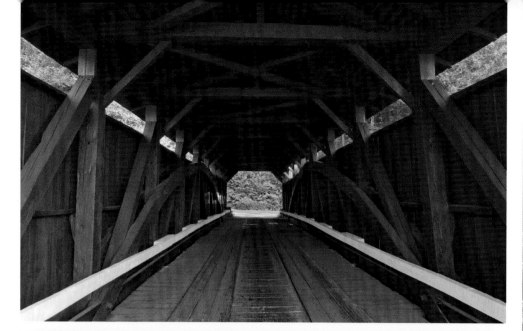

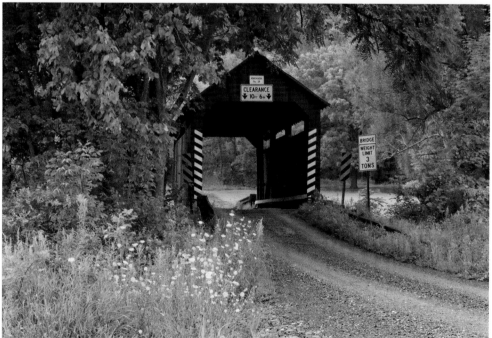

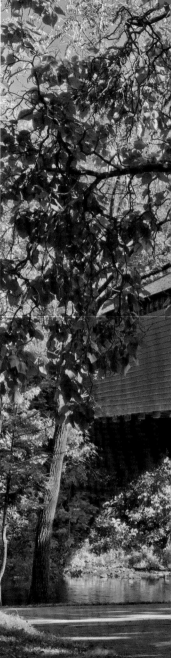

[Top] While the interior of many covered bridges is left unpainted, Davis Covered Bridge, like a few others, has a beautifully painted interior. The 87-foot-long bridge in Columbia County displays the Burr truss, the most common truss in Pennsylvania's covered bridges. Davis Covered Bridge was built in 1875 for $1,248.00.

[Bottom] The 60-foot-long Johnson Covered Bridge in Columbia County spans Mugser Run. It was built in 1882 at a cost of $799.00 near the farm of Adam M. Johnson, who owned a boot-and-shoe store nearby. It was added to the National Register of Historic Places in 1979.

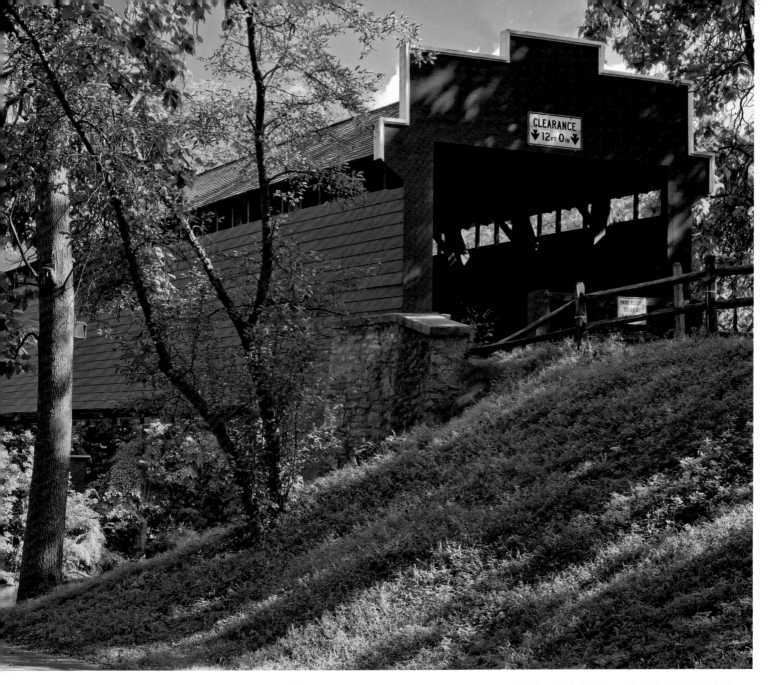

With a 204-foot length, Wertz's/Wertz/ Red Covered Bridge in Berks County is the longest single-span covered bridge in Pennsylvania. Located at the Berks County Heritage Center, it was built in 1867 for $7,650.00. It spans the Tulpehocken Creek and the former Union Canal.

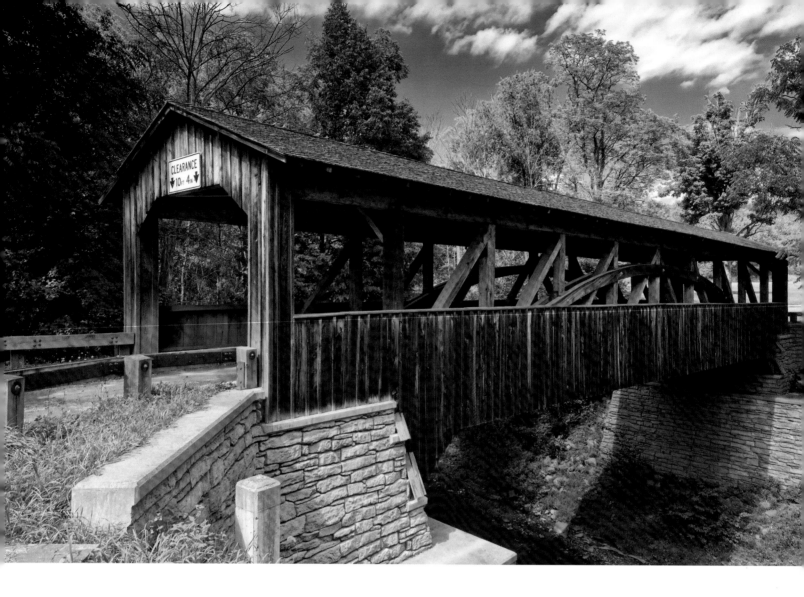

Knapp's / Luther's Mill / Brown's Creek
Covered Bridge is the only covered bridge
in Bradford County. Located in a tranquil
rural setting, it was built in 1853 to
serve the farming area outside Luther's
Mill. The bridge had a major restoration
beginning in 2000, and it now the pride
of the region.

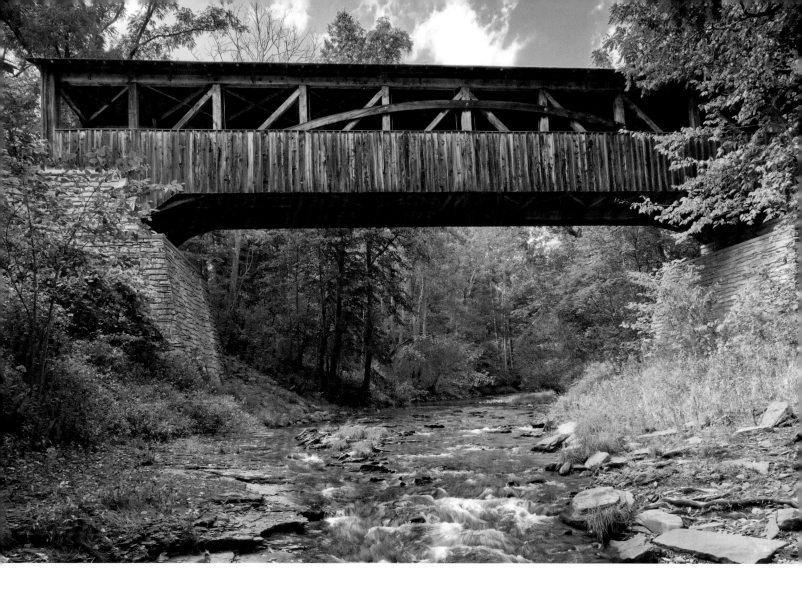

The 95-foot-long Knapp's / Luther's Mill / Brown's Creek Covered Bridge in Bradford County is reported to be the highest covered bridge in the state, spanning Brown's Creek, 30 feet above the streambed. It was added to the National Register of Historic Places in 1980.

The 110-foot-long Knecht's/Sleifer's Covered Bridge in Bucks County spans Cooks (Durham) Creek. Built of hemlock lumber in 1873, it employs the Town truss, common in Bucks County covered bridges. Sleifer Valley used to be known as a fertile region where German settlers established homesteads in the early 1700s.

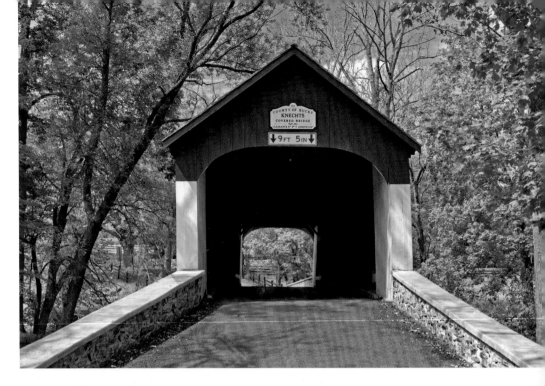

The portal of many covered bridges displayed warnings and rules to protect the bridge, as seen here on the 1832 South Perkasie Covered Bridge in Bucks County. "$5 Fine for Any Person Riding or Driving Over This Bridge Faster Than a Walk or Smoking Segars On."

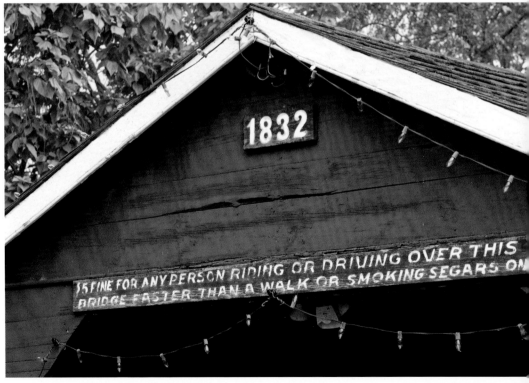

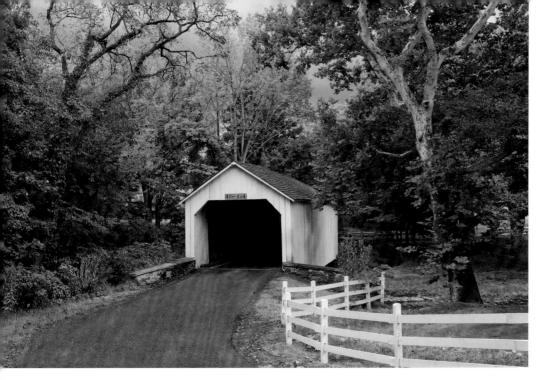

Named for John A. Loux, a long-tenured justice of the peace, 60-foot-long Loux Covered Bridge in Bucks County was built in 1874 after local residents petitioned for the bridge due the dangerous crossing of Cabin Run. Built of hemlock, it's the only all-white covered bridge in the county.

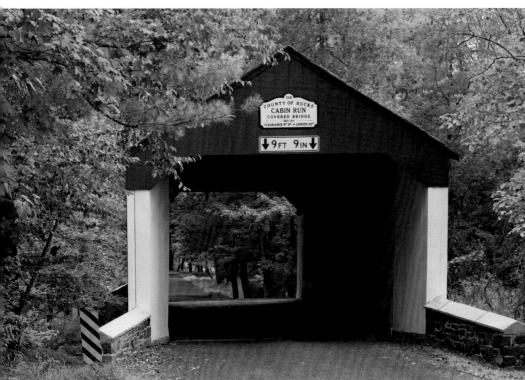

The 15-foot-long Cabin Run Covered Bridge was built in 1871 over Cabin Run Creek, named for the concentration of log and stone cabins that lined its banks. During the American Revolutionary War, the area was frequented by the "Doan Boys," a notorious gang of Quaker brothers well known as British spies.

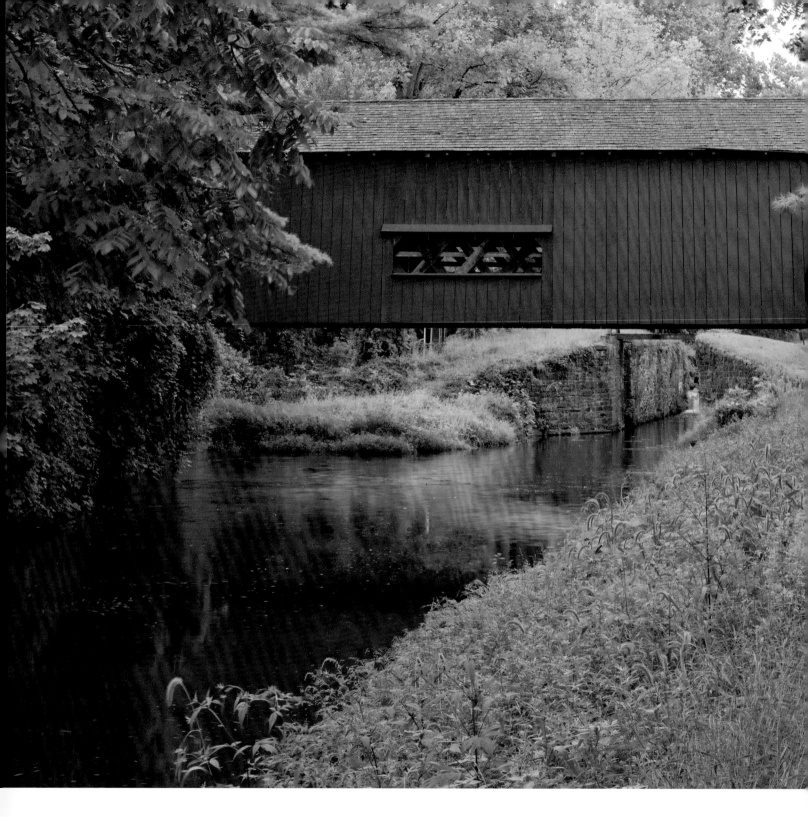

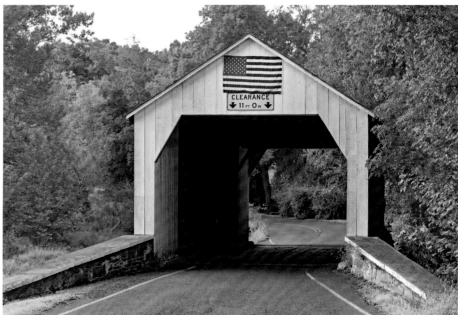

Uhlerstown Covered Bridge in Bucks County is the only covered bridge that crosses the Delaware Canal. It is named for Michael Uhler, canal boat builder, founder of Uhlerstown, and first postmaster. Believed to have been originally built in 1832 of oak timbers, it is 110 feet long.

[Top] Rare and unique Mean's Ford Bridge in Ralph Stover State Park, Bucks County, is the only surviving "boxed pony truss bridge" in Pennsylvania. It was built in the1860s over Tochickon Creek. Not a typical covered bridge, it is nevertheless listed as a covered bridge due the trusses being covered.

[Bottom] Although the National Register lists the year of construction of Erwinna Covered Bridge in Bucks County as 1871, county records indicate it was actually built in 1832. Only 56 feet long, it is the shortest covered bridge in the county. Named for American Revolutionary War colonel Arthur Erwin, it spans Lodi Creek.

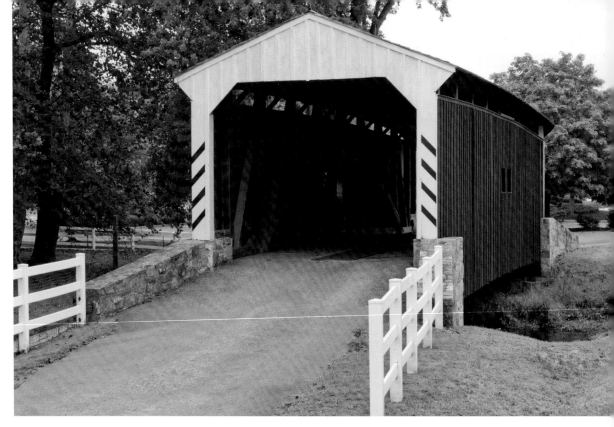

Willow Hill Covered Bridge in Lancaster County is unique in a couple of ways. Rather than being located in a rural setting, it is surrounded by strip malls. Second, it is a reconstruction of two historic bridges, the 1871 Miller's Farm Covered Bridge and the 1855 Good's Fording Covered Bridge.

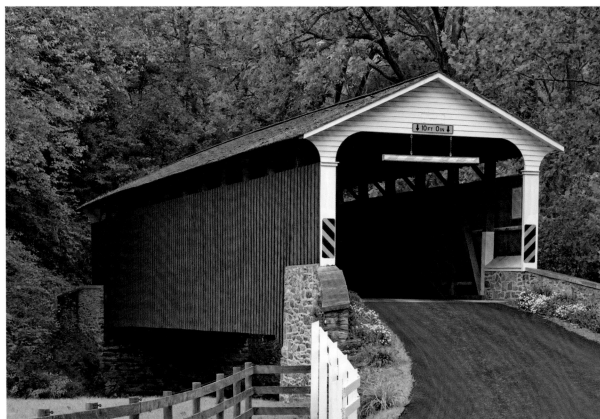

Built in 1880, Mercer's Mill / Mercer's Ford Covered Bridge spans the East Branch of Octoraro Creek in Lancaster and Chester Counties. Although owned by the two counties, the approximately 86-foot-long bridge is also cared for by local residents with their beautiful floral plantings and gardening.

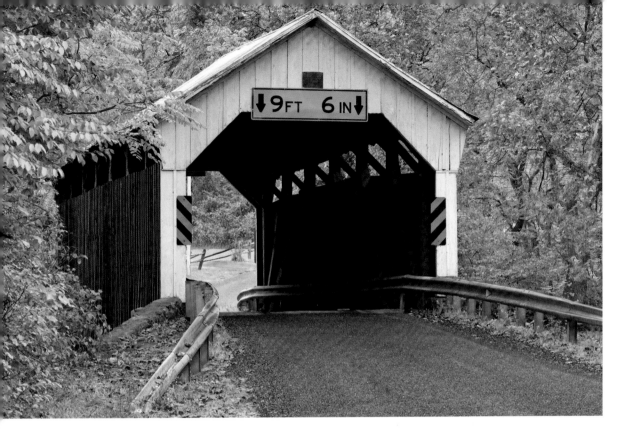

The 1880 Factory/Horsham Covered Bridge in Union County spans White Deer Creek. The bridge received its name "Factory" from a former woolen mill located nearby along the creek and destroyed in a fire in 1928. The 60-foot-long bridge was added on the National Register of Historic Places in 1980.

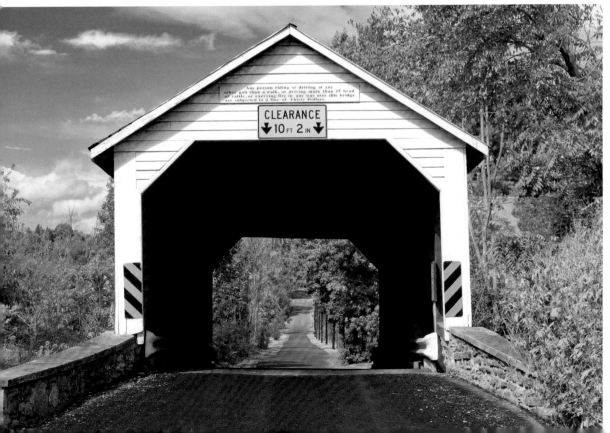

Hassenplug Covered Bridge in Union County, besides being the oldest covered bridge in Pennsylvania, shares the claim with Hyde Hill Covered Bridge in New York as the oldest existing covered bridge in the United States. Built in 1825, the 80-foot-long bridge spans Buffalo Creek and still used for vehicle traffic.

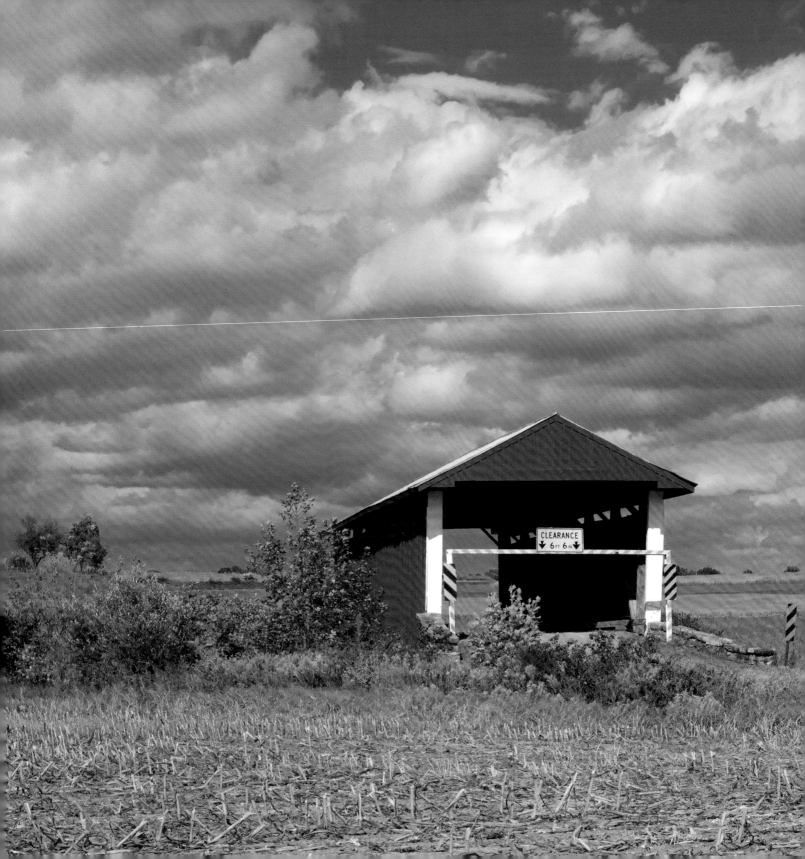

Although many of Pennsylvania's covered bridges are found along forested streams, Hayes Covered Bridge sits in open agriculture fields in Union County. The 70-foot-long bridge was built in 1882 and spans Buffalo Creek. It was added to the National Register of Historic Places in 1980.

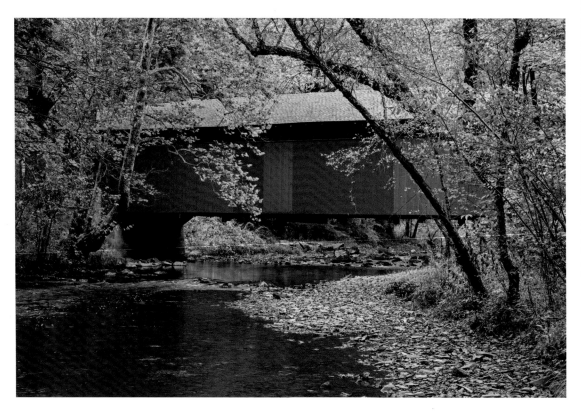

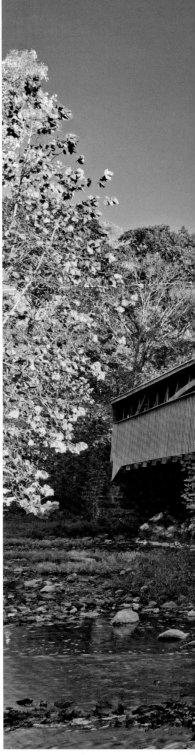

Built along a former stagecoach route in 1860, Little Gap Covered Bridge in Carbon County spans Aquashicola Creek. The bridge was added to the National Register of Historic Places in 1980. Although it has been damaged by oversized vehicles over the years, this beautiful bridge is in very good condition.

Although there are some conflicting dates as to when the Academia/Pomerory Covered Bridge in Juniata County was originally built, there are no conflicts that the 278-foot-long covered bridge is the longest in Pennsylvania. In the early 20th century, it was an important crossing over Tuscarora Creek for farmers and students.

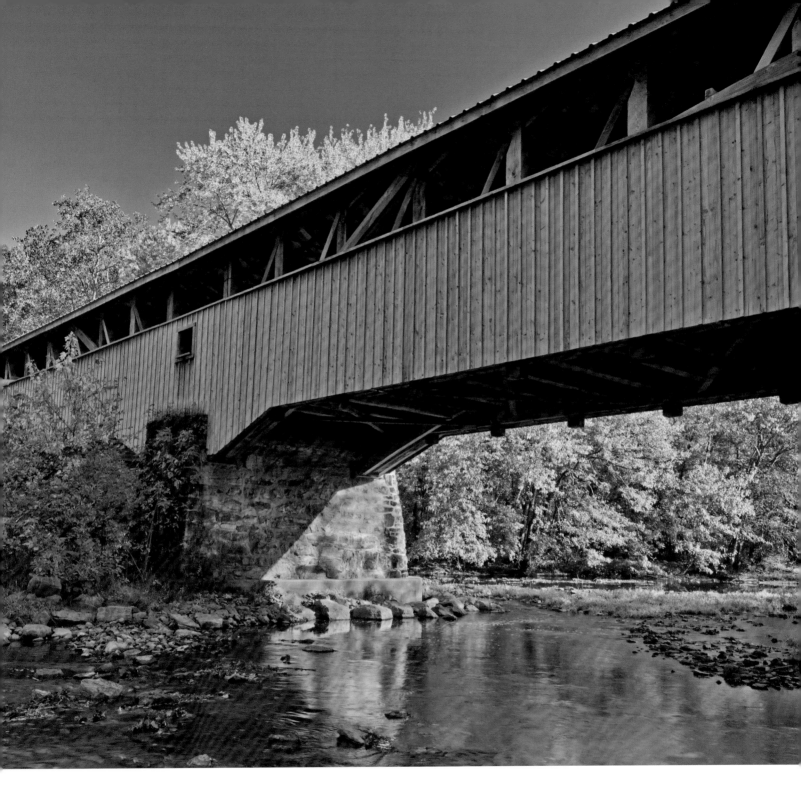

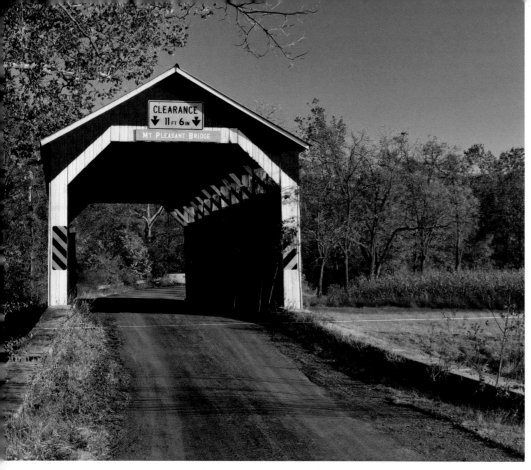

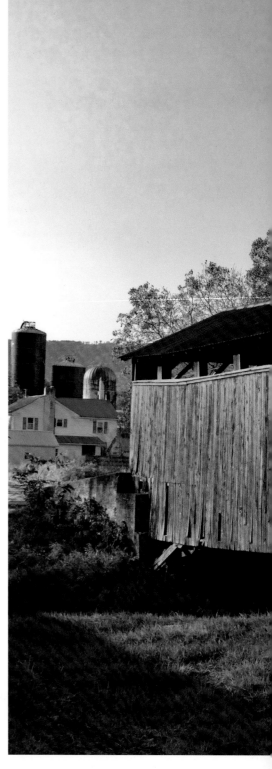

The 60-foot-long Mount Pleasant Covered Bridge in Perry County spans Sherman's Creek. It was constructed in 1918 in an area of scenic farmland. The bridge was added to the National Register of Historic Places in 1980.

Kochebderfer Covered Bridge in Perry County sits seemingly forgotten to the side of a modern highway, waiting for some tender loving care and money to restore its 1919 glory when it was built. Unfortunately, it will cost much more than the original $2.380.00 cost of construction.

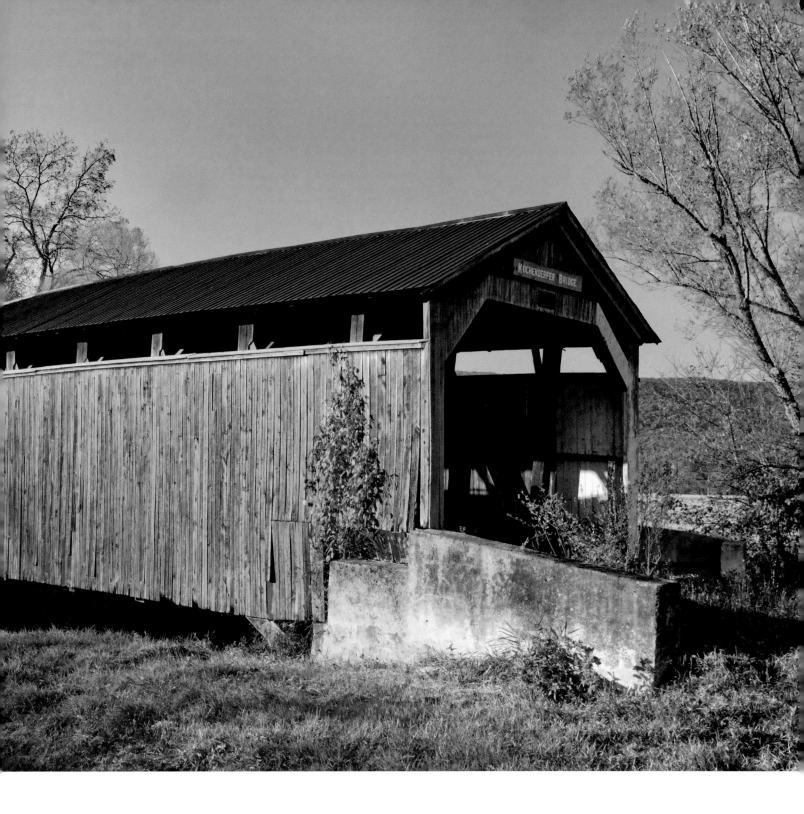

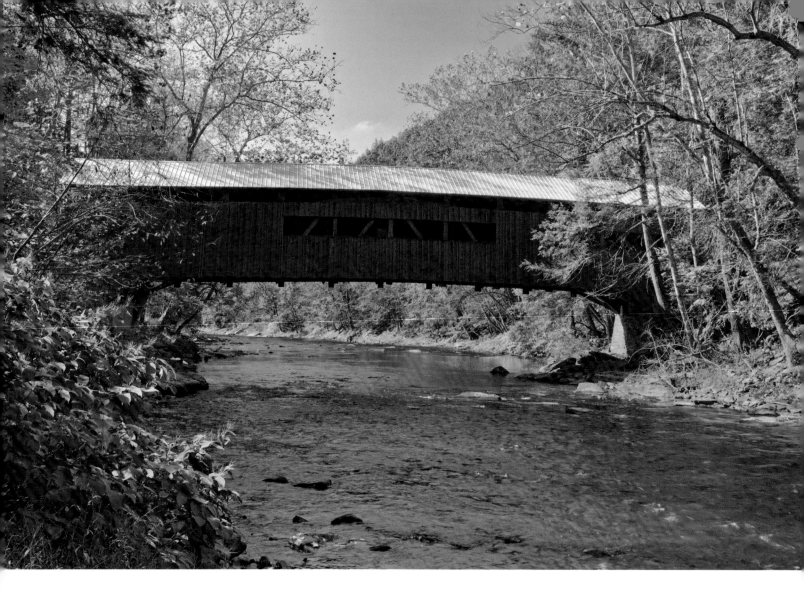

The Josiah Hess / Laubach Covered Bridge in Columbia County was built at a cost of $1,349.50 in 1875 over Huntington Creek. It was named for Josiah Hess, who owned a farm and sawmill nearby. Josiah was a fourth generation to Johann Hess, who emigrated from Scotland in 1730 at age sixteen.

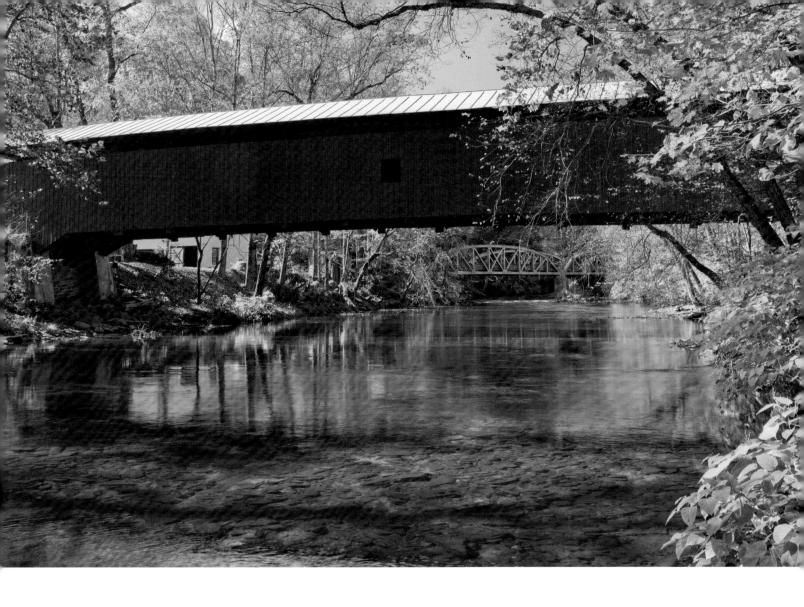

Swiftwater Covered Bridge in Columbia County, at a length of 151 feet, spans Big Fishing Creek in the borough of Swiftwater. It is considered to be the second-oldest and second-longest covered bridge in the county.

41

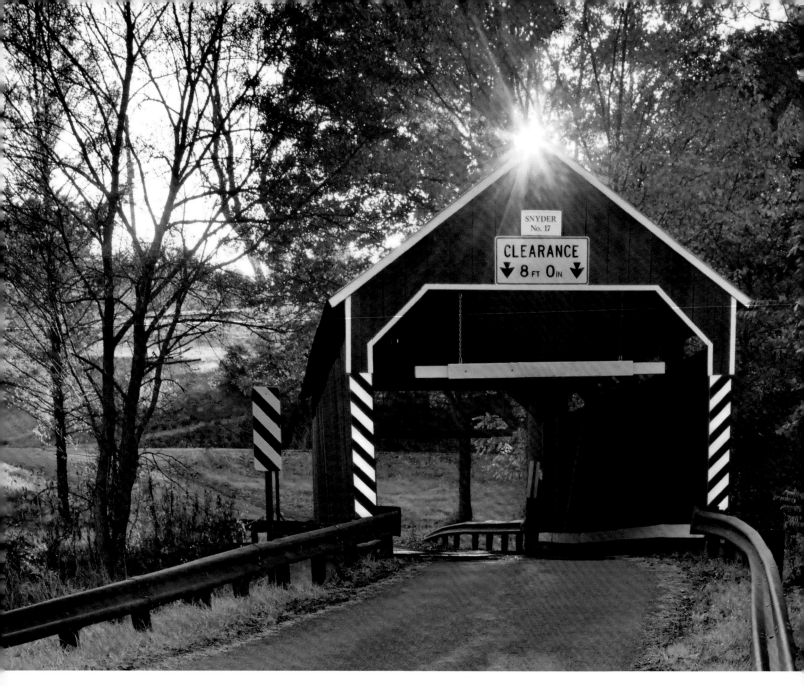

Built in 1876 over the North Branch of Roaring Creek, Snyder Covered Bridge in Columbia County was named for the nearby John Snyder's gristmill. The 60-foot-long bridge was added to the National Register of Historic Places in 1979.

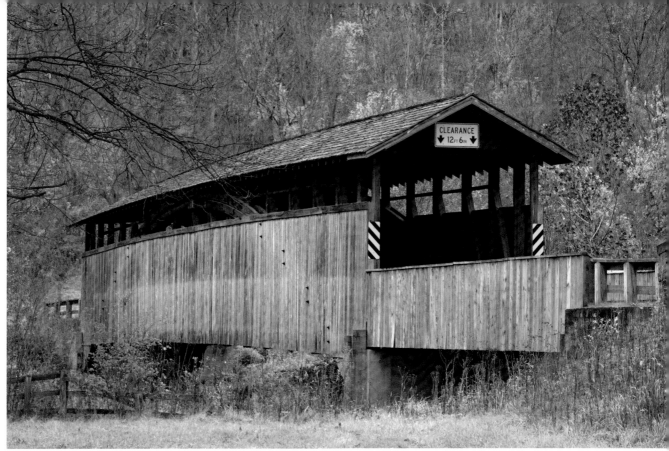

The 126-foot-long Claycomb/Reynoldsdale Covered Bridge was originally built in 1880 at Reynoldsdale, Bedford County. In 1975 it was moved 15 miles north to serve as the entrance to Old Bedford Village, an open-air history museum. The bridge is left unpainted and displays a beautiful natural weathered appearance.

Refurbished in 1992, Jackson's Mill Covered Bridge in Bedford County is now considered by many as one of the most beautiful covered bridges in Pennsylvania. The 91-foot-long bridge was originally constructed in 1875 over Brush Creek and named for M. J. Jackson, owner of a nearby grist- and sawmill.

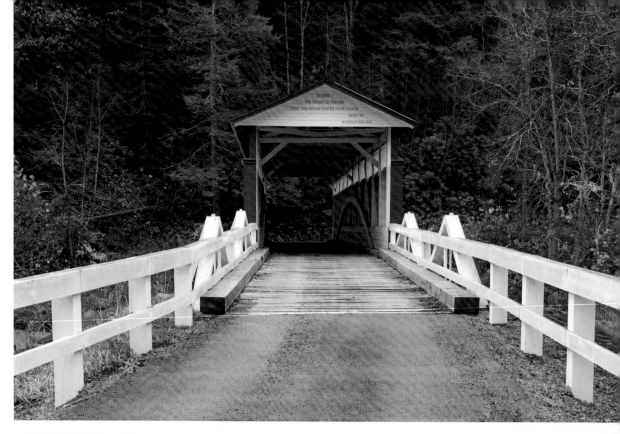

Dr. Knisley Covered Bridge in Bedford County was constructed in 1867 over Dunnings Creek. It is a beautifully maintained, privately owned bridge, closed to vehicle traffic. It is hoped that visitors will respect the property and that the owner will not be forced to close the area to the public.

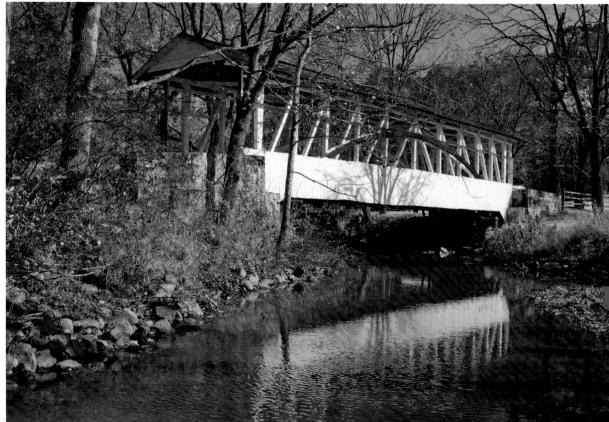

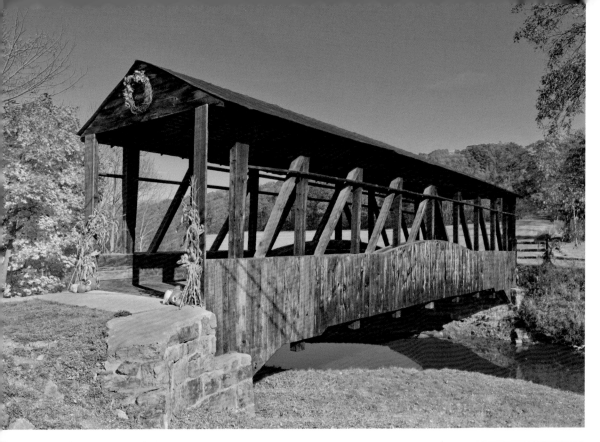

The beautifully maintained, privately owned Cuppett's / Cuppetts / New Paris Covered Bridge in Bedford County was built in 1882 over Dunnings Creek. The 60-foot-long bridge is said to have been built in only five months at a cost of $780.00. The current owners take great pride in decorating it for different holidays.

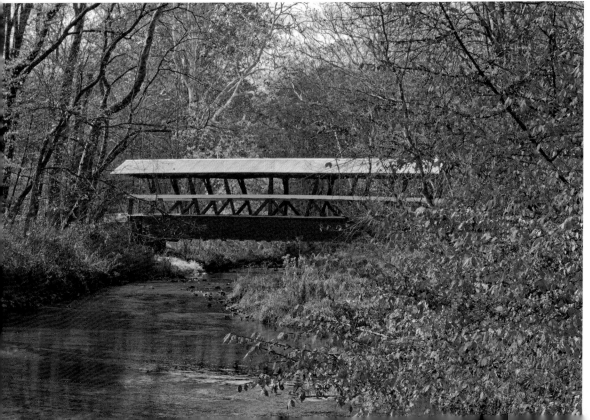

The county-owned Colvin/ Calvin/Shiller Covered Bridge on the boundary of Shawnee State Park in Bedford County was built in 1880. The 66-foot-long bridge crosses Shawnee Creek and is open to vehicle traffic. This beautiful bridge was refurbished in the late 1990s.

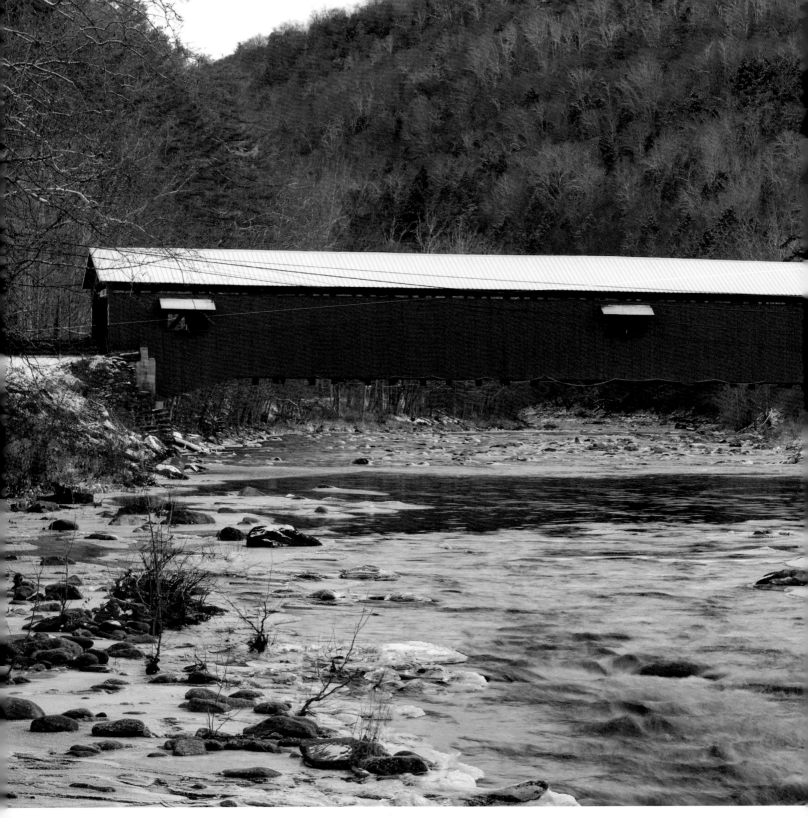

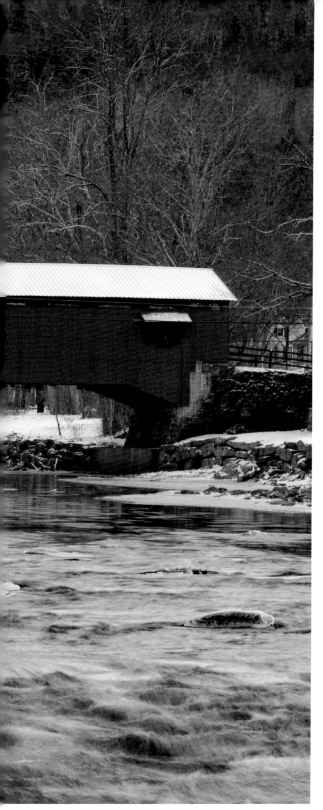

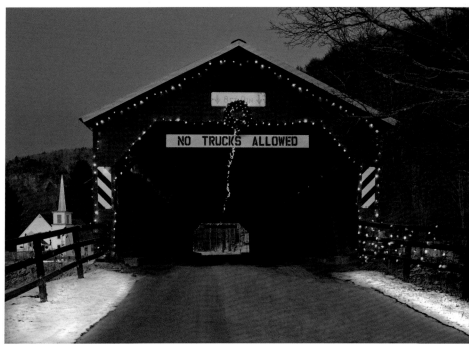

The Forskville Covered Bridge in Sullivan County, with its beautiful holiday decorations and the Forksville Methodist Church, makes a Christmas card scene come to life.

It's been said that Forksville Covered Bridge in Sullivan County, "over the rocky Loyalsock Creek," is "one of the most attractive settings in the state." The 152-foot-long bridge, built in 1850, was used as the logo for the Farmers' & Mechanics' Home Mutual Insurance Company of Sullivan County.

47

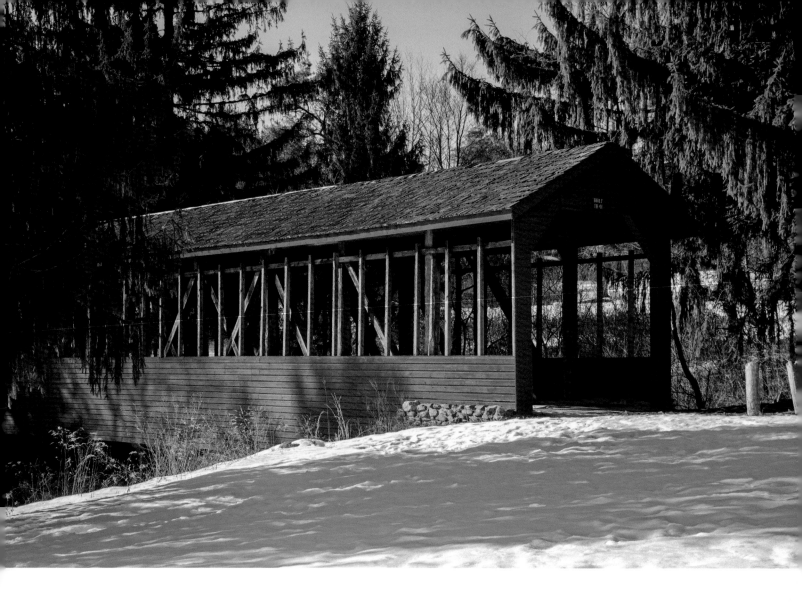

Buck's/Harrity Covered Bridge, Carbon County,
was built in 1882 over Pohopoco Creek. In 1970
the U.S. Army Corps of Engineers dammed
the creek to created Beltzville Lake for flood
control and recreation. To preserve the bridge,
the Corps moved it to higher ground, and it's
now protected in Beltzville State Park.

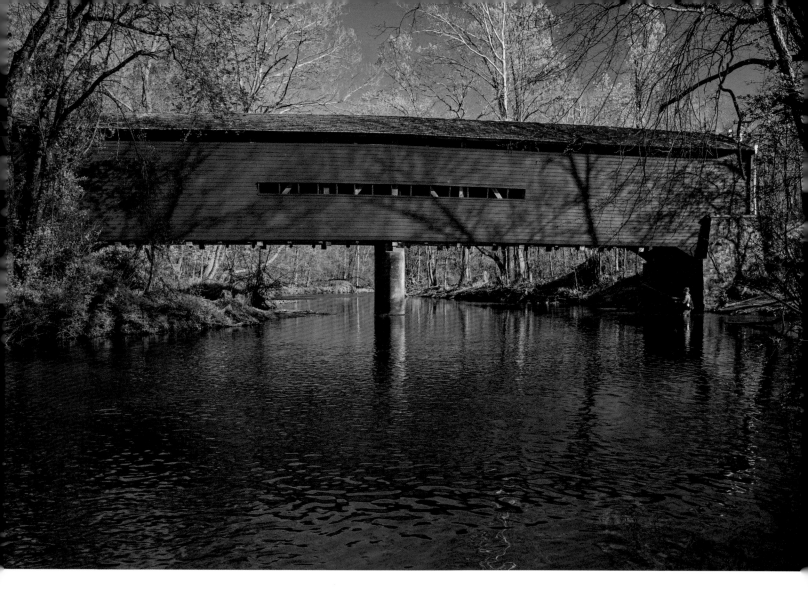

Sheeder-Hall/Hall's Covered Bridge, built in 1850 over French Creek, is the oldest surviving covered bridge in Chester County. Its location is a favorite spot for anglers in spring. The 102-foot-long bridge was a crucial component of transportation in the nineteenth century for the area.

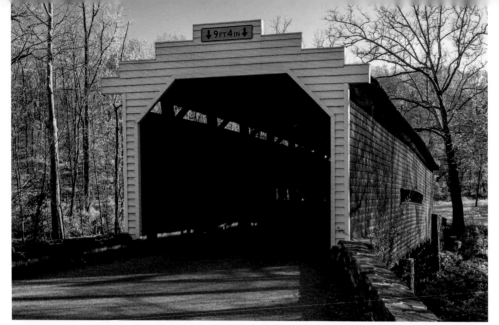

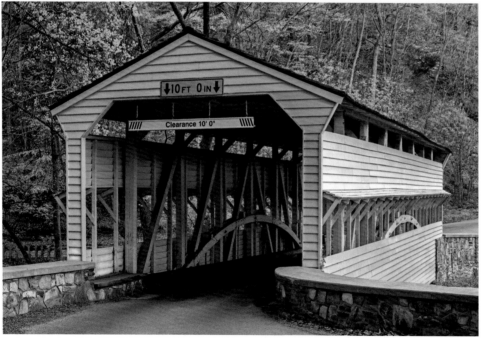

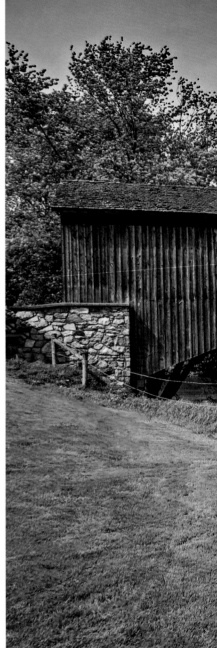

[Top] *Although well over 170 years old, Sheeder-Hall/Hall's Covered Bridge in Chester County is still a heavily used bridge. The Pennsylvania Department of Transportation estimates over a thousand vehicles cross the single span daily. It was added to the National Register of Historic Places in 1973*

[Bottom] *The current Knox / Valley Forge Covered Bridge in Valley Forge National Historical Park, Chester County, was built in 1865 at a cost of $1.179.00 over Valley Creek. Generally it's known as "Knox Bridge," but with uncertainty as to for whom it was named, Senator Philander C. Knox or General Henry Knox.*

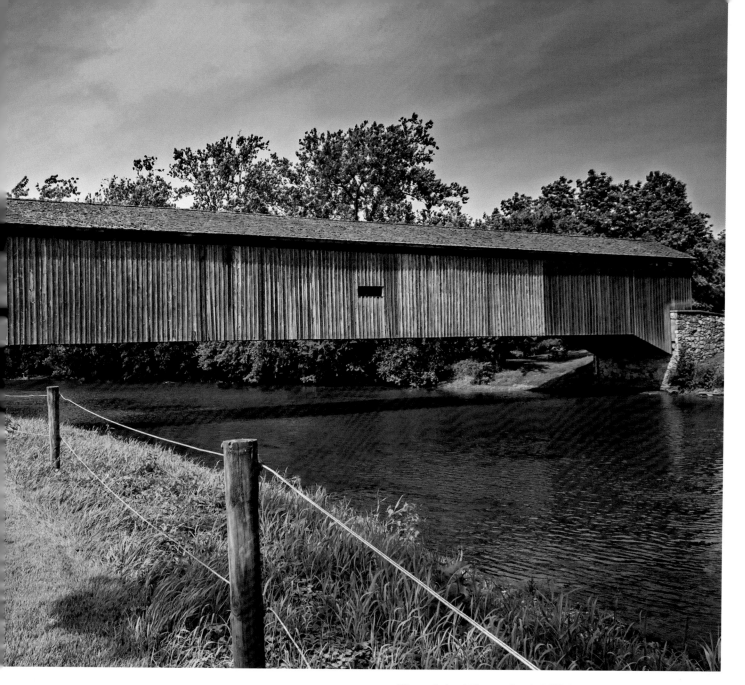

The original Hunsecker's Mill Covered Bridge, Lancaster County, was built in 1843 over Conestoga Creek; however, it has been swept off its abutment several times during floods. The most recent flooding occurred in 1972 during Hurricane Agnes. It was rebuilt shortly afterward by the commonwealth of Pennsylvania at a cost of $321,302.00.

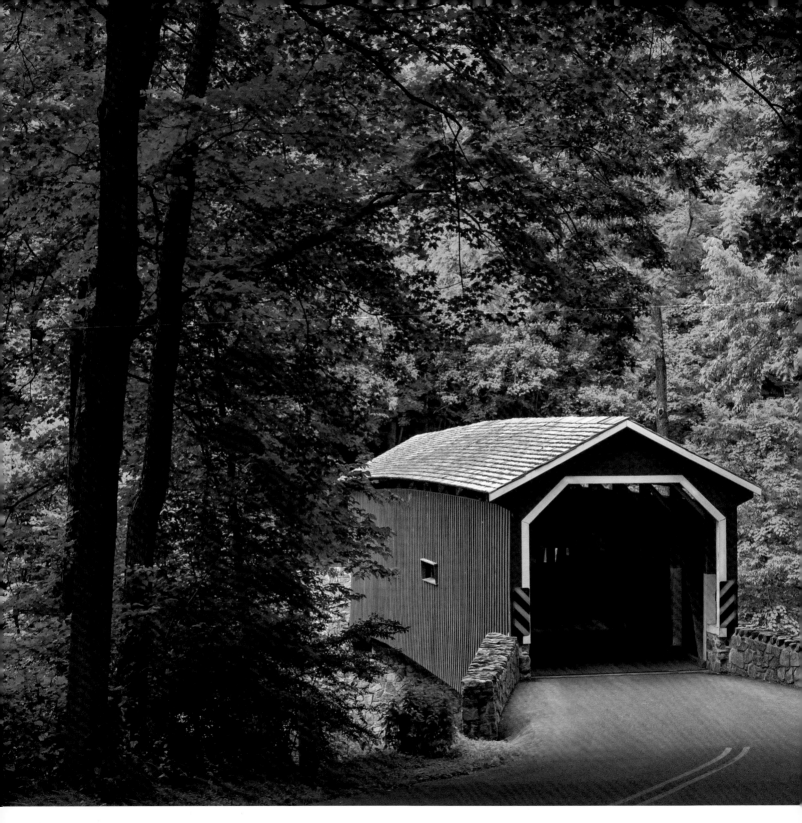

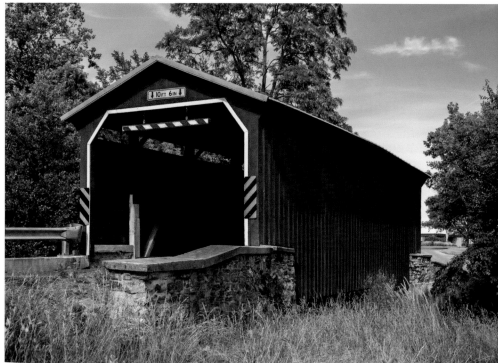

Landis Mill / Little Conestoga #1 Covered
Bridge in Lancaster County is a victim
of urban sprawl. Built in 1873 in what
was a rural area, today it is surrounded
by shopping centers, highways, and
development. This beautiful 53-foot-long
bridge stands in testament of what we are
losing at an alarming rate.

Like others, Kurtz's Mill / Baer's Mill /
Keystone Mill Covered Bridge in Lancaster
County was a victim of flooding. It was
built over Mill Creek in 1876, and the
floodwaters of Hurricane Agnes moved it a
significant distance downstream. In 1975 it
was repaired and moved by trailer 15 miles
downstream to Lancaster County Park.

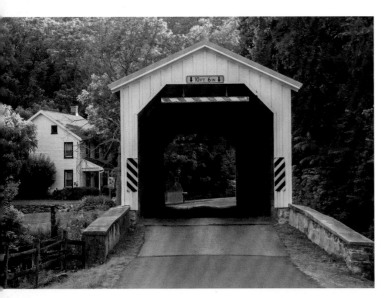

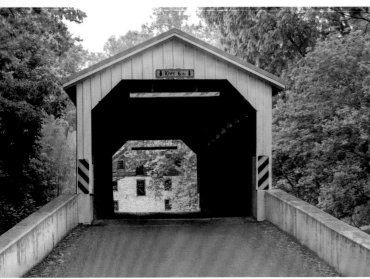

[Top] Neff's Mill / Pequea #7 Covered Bridge in Lancaster County was originally built in 1824 and known as Bowman's Mill Covered Bridge. It was rebuilt in 1875 and received its current names. Its 102-foot-length spans Pequea Creek. It was added to the National Register of Historic Places in 1980.

[Bottom] Baumgardner's / Pequea #10 Covered Bridge spans Pequea Creek in Lancaster County. Originally built in 1860, it was restored and raised 4 feet and lengthened 9 feet in 1987 after damage by floodwaters. The bridge's name was given by Thomas Baumgardner, who owned the adjacent sawmill and gristmill.

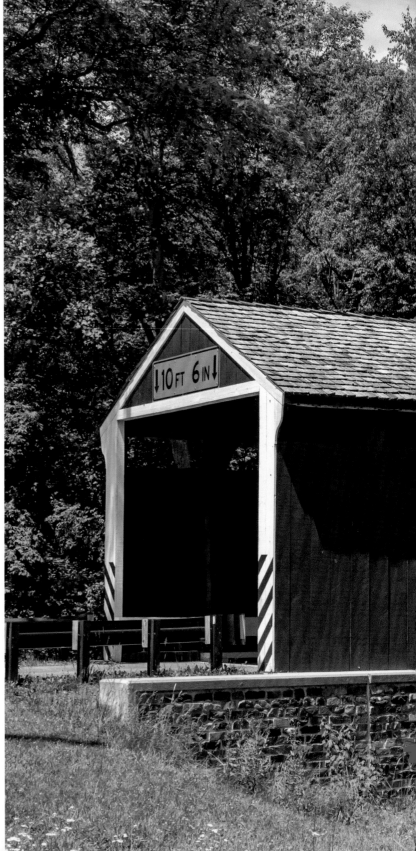

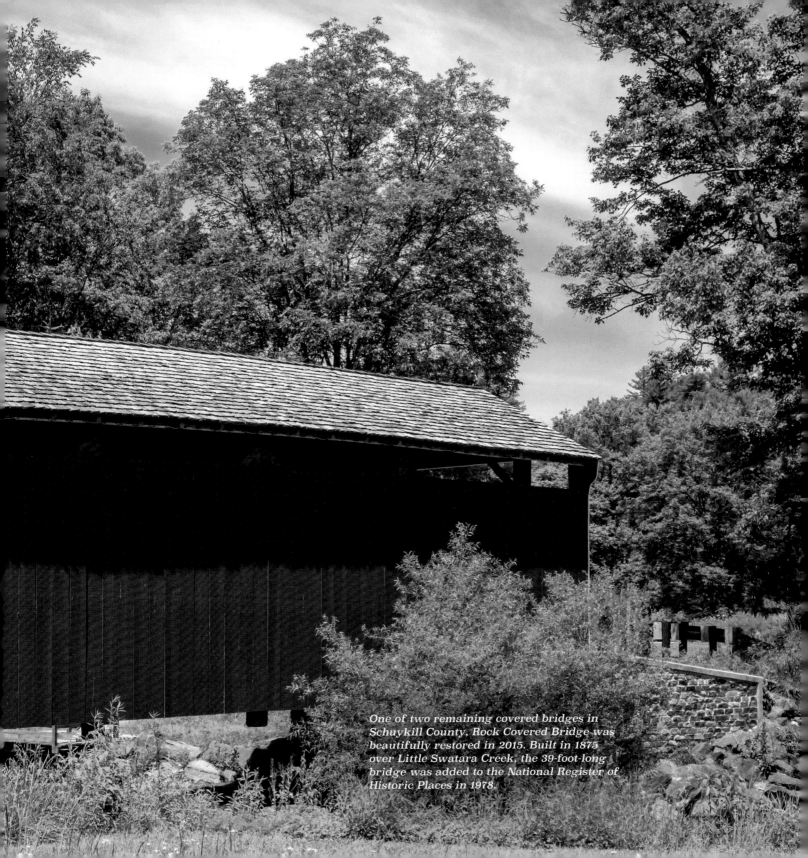

One of two remaining covered bridges in Schuykill County, Rock Covered Bridge was beautifully restored in 2015. Built in 1875 over Little Swatara Creek, the 39-foot-long bridge was added to the National Register of Historic Places in 1978.

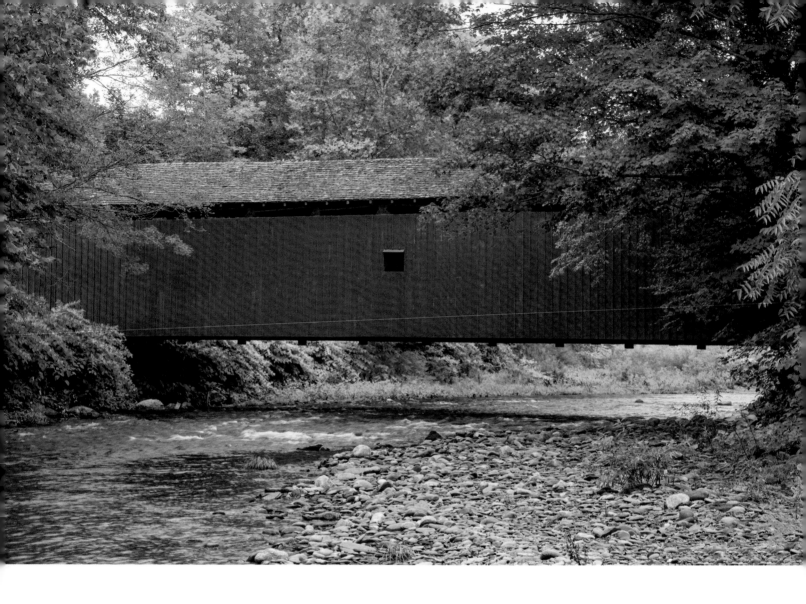

The 110-foot-long Sonestown Covered Bridge in Sullivan County spans Muncy Creek. It was originally built in 1850 to provide access to a nearby gristmill. The bridge has had an unfortunate history of being damaged by floodwaters several times throughout its life, as recently as 2018, and it was repaired in 2021.

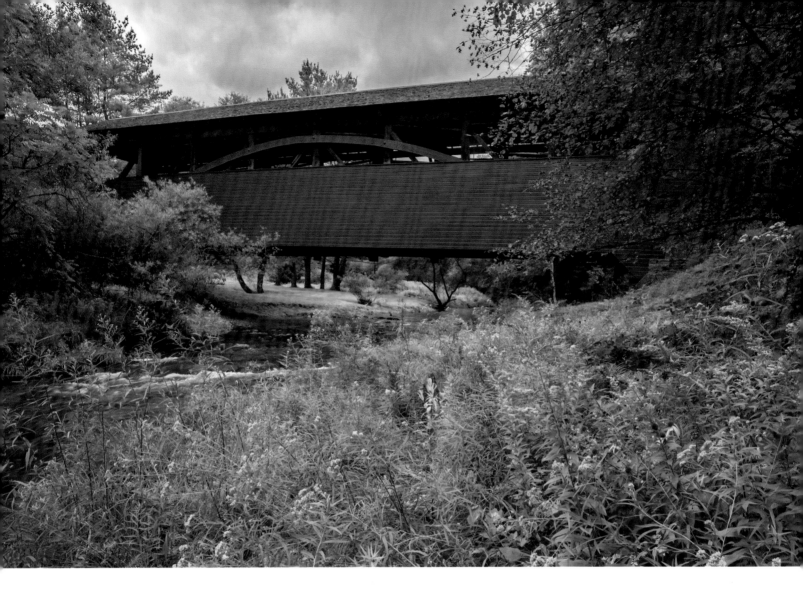

Cogan House / Buckhorn Covered Bridge
in Lycoming County was built in 1877
over Larry's Creek. It is said it provided a
steady flow of tannery and sawmill traffic
until the area's forests were clear-cut in
the early twentieth century. Today the
beautiful 92-foot-long bridge sits at the end
of a dead-end remote road.

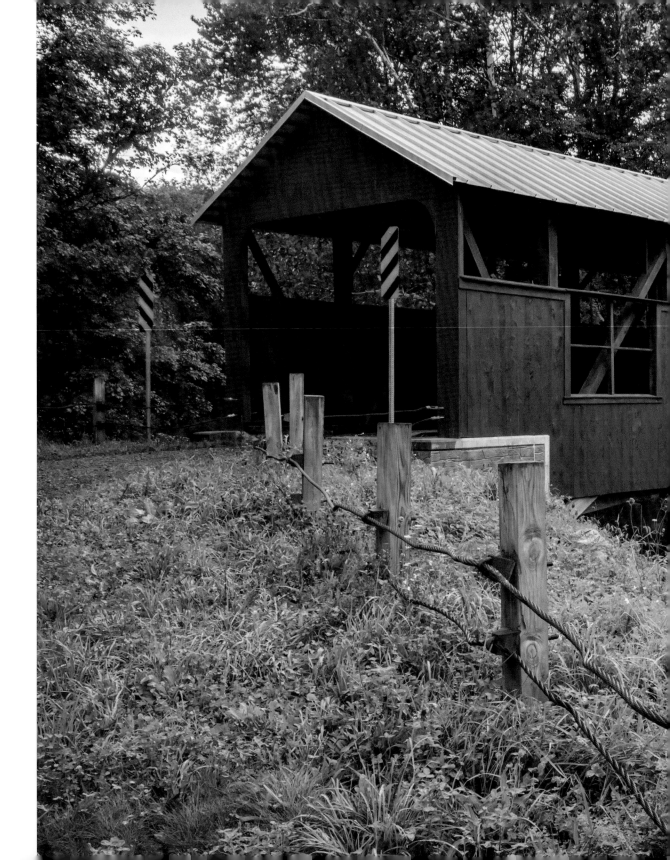

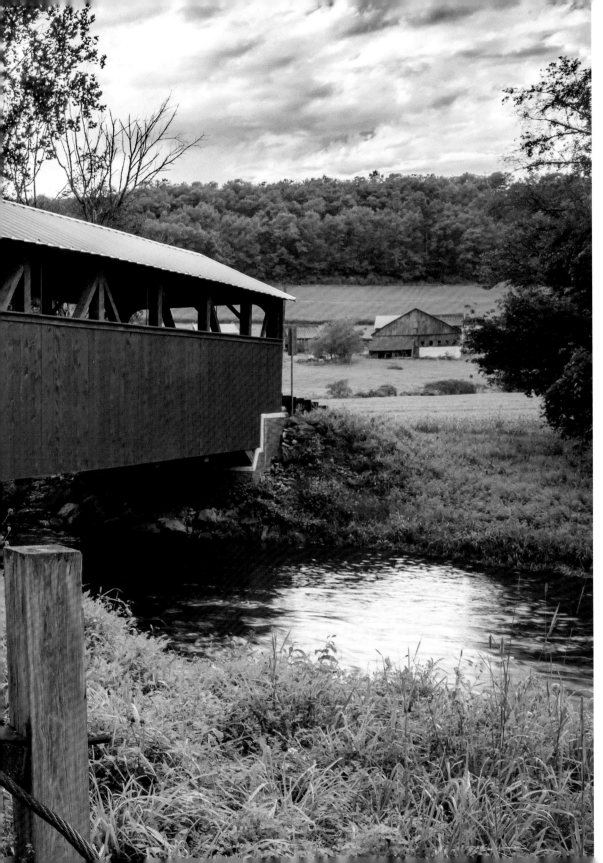

Lairdsville/Frazier/ Moreland Covered Bridge spans Little Muncy Creek in a very scenic area of Lycoming County. Originally built in 1888 over Little Muncy Creek, the 77-foot span was beautifully restored in 2011. It was added to the National Register of Historic Places in 1980.

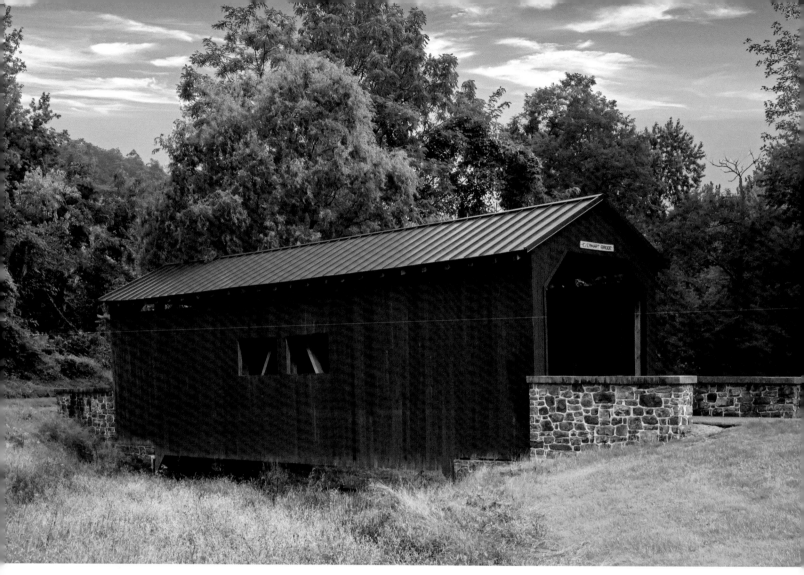

The 52-foot-long Fort Hunter's / Everhart Covered Bridge in Dauphin County may be the longest-traveling covered bridge in Pennsylvania. Originally built in 1881 over Little Buffalo Creek in Perry County, after being scheduled for demolition in 1940 it was purchased by Margaret Wister Meigs, dismantled, and moved to Fort Hunter, north of Harrisburg.

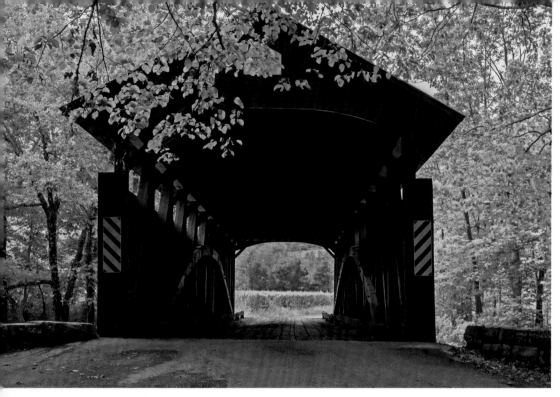

Keefer Station Covered Bridge in Northunberland County was built in 1888 at a cost of $882.00. It was beautifully restored in 2000. The 109-foot-long bridge spans Shamokin Creek and was added to the National Register of Historic Places in 1979.

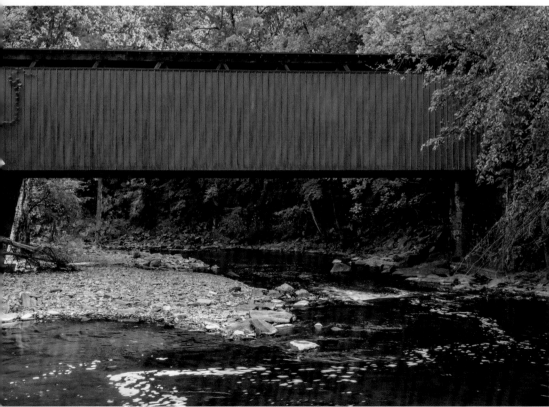

Constructed in 1855, Thomas Mill Covered Bridge is not only the last surviving covered bridge in the city of Philadelphia but also the only covered bridge left in any major US city. Approximately 87 feet long, the bridge spans Wissahickon Creek in a natural setting in the city's Fairmount Park.

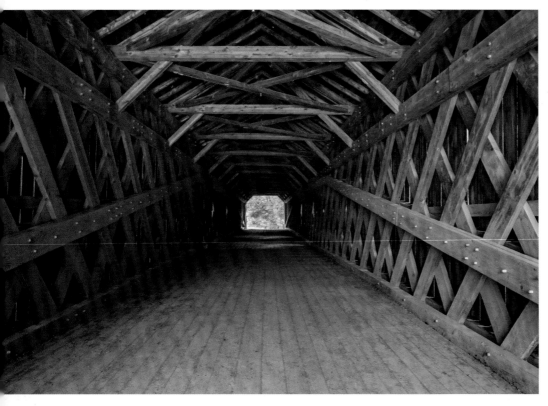

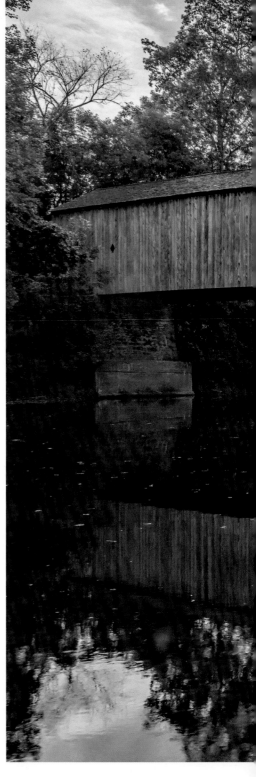

Although the Burr truss is the most common truss in Pennsylvania's covered bridges, the Town or lattice truss seems to predominate in Bucks County, as seen here at Twining Ford / Schofield Covered Bridge. The Town truss is named for Ithiel Town, an early-nineteenth-century designer and bridge builder from Connecticut.

The original 1873 Twining Ford / Schofield Covered Bridge, spanning Neshaminy Creek in Tyler State Park, was destroyed by arson in 1991. Concerned citizens raised $360,000.00 to build a new bridge. For six years, volunteers, contractors, and government agencies worked together to build the new 164-foot-long bridge, by hand, which opened in 1997.

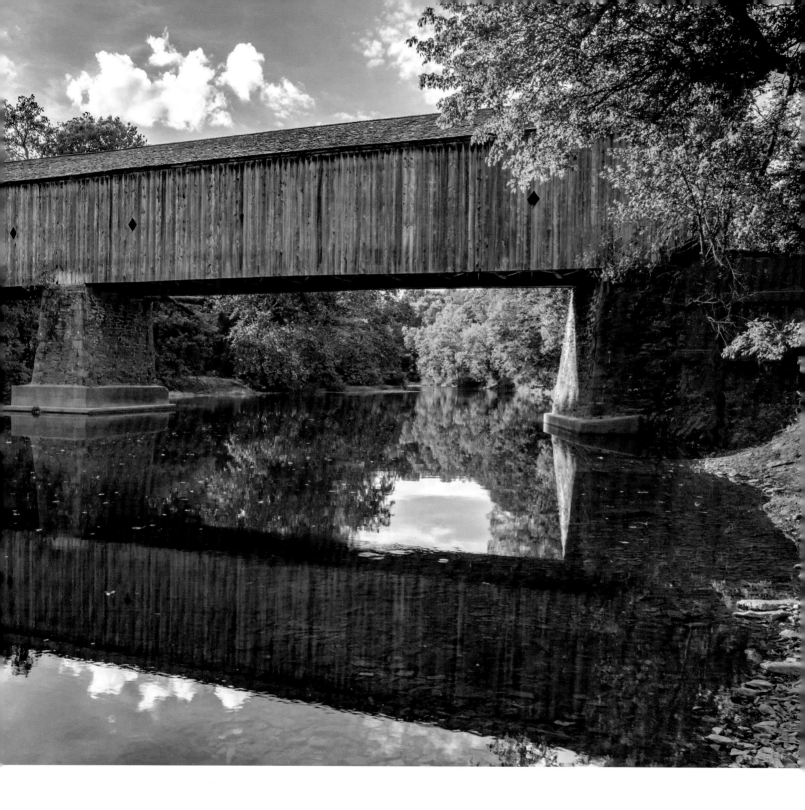

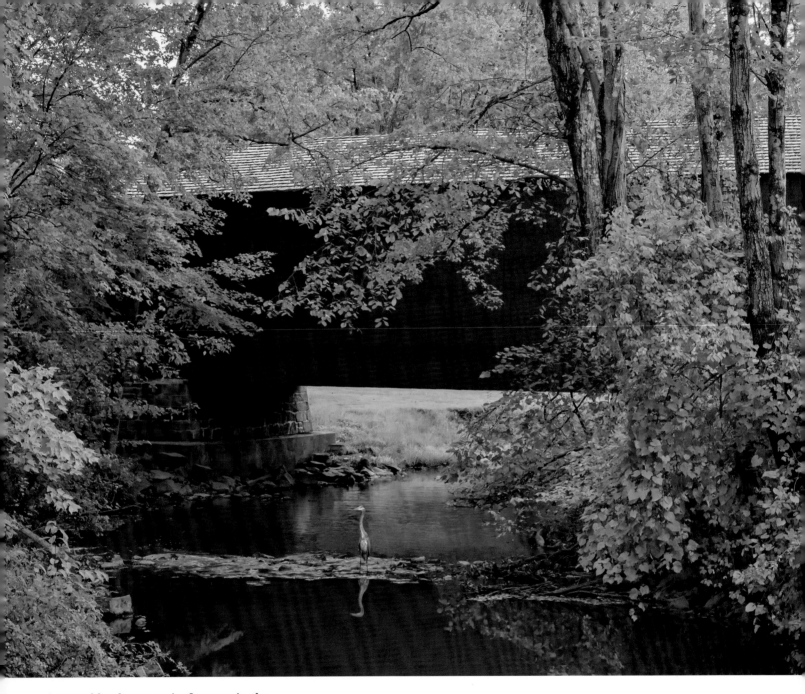

A great blue heron waits for prey in the shadow of Pine Valley / Iron Hill Covered Bridge in Pine Run Creek, Bucks County. The 81-foot-long bridge was built in 1842 of native hemlock and pine at a cost of $5553.50, and it was added to the National Register of Historic Places in 1980.

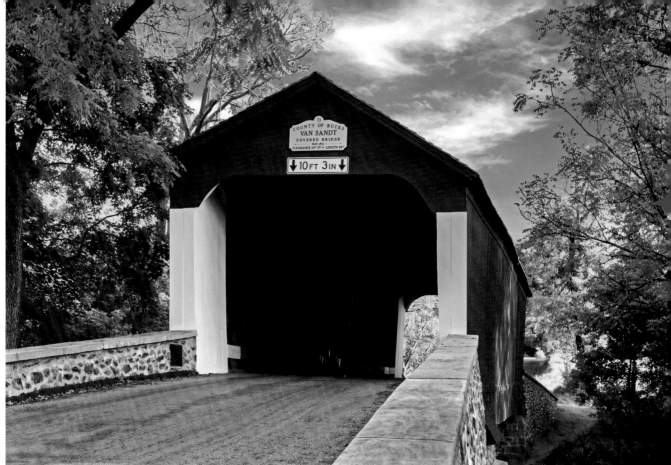

*Van Sant / Van Sandt / Beaver Dam
Covered Bridge in Bucks County, near
Washington Crossing Historic Park, spans
Pidcock Creek. The 86-foot-long bridge
was built in 1875. Rumors persist that the
bridge is haunted by a young woman who
gave birth out of wedlock and flung her
baby over the bridge, then hanged herself.*

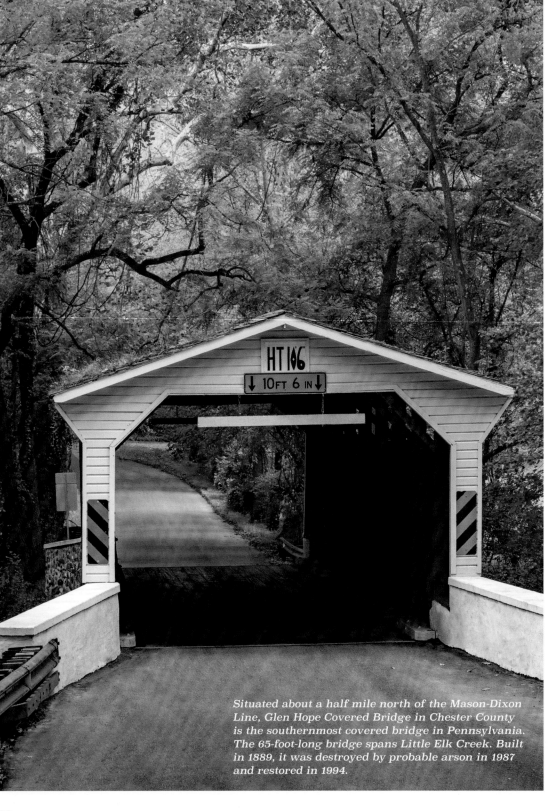

Situated about a half mile north of the Mason-Dixon Line, Glen Hope Covered Bridge in Chester County is the southernmost covered bridge in Pennsylvania. The 65-foot-long bridge spans Little Elk Creek. Built in 1889, it was destroyed by probable arson in 1987 and restored in 1994.

HT 166

↓ 10 FT 6 IN ↓

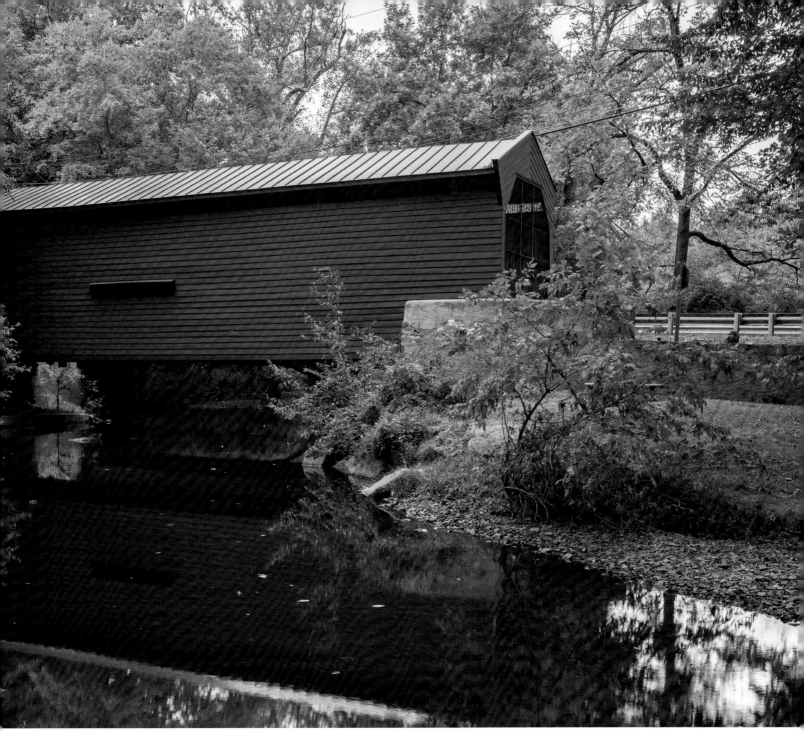

Built in 1860 to be "hi and wide as a load of hay," Bartram's/ Goshen Covered Bridge spans Chester and Delaware Counties over Crum Creek. It's the last of thirty covered bridges that once existed in Delaware County. It was added to the National Register of Historic Places in 1980.

67

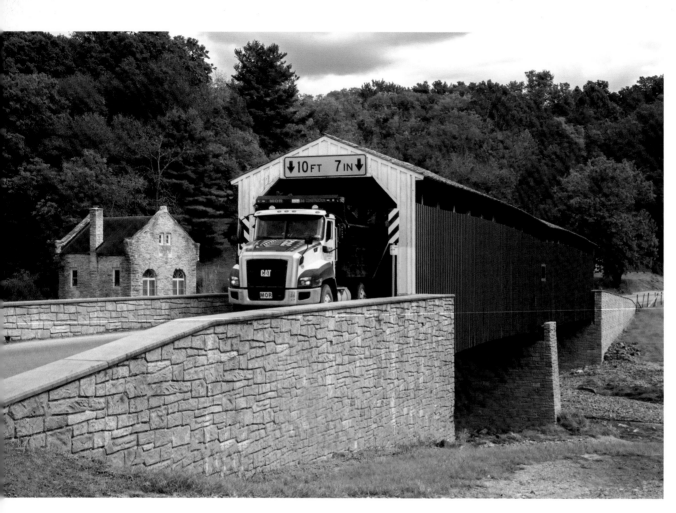

Pine Grove Covered Bridge, spanning
the East Branch of the Octoraro Creek
between Lancaster and Chester Counties,
like some other covered bridges in the
commonwealth, has been reinforced to
accommodate modern traffic. Originally
built in 1884, the 204-foot-long two-span
bridge is the longest covered bridge in
Lancaster County.

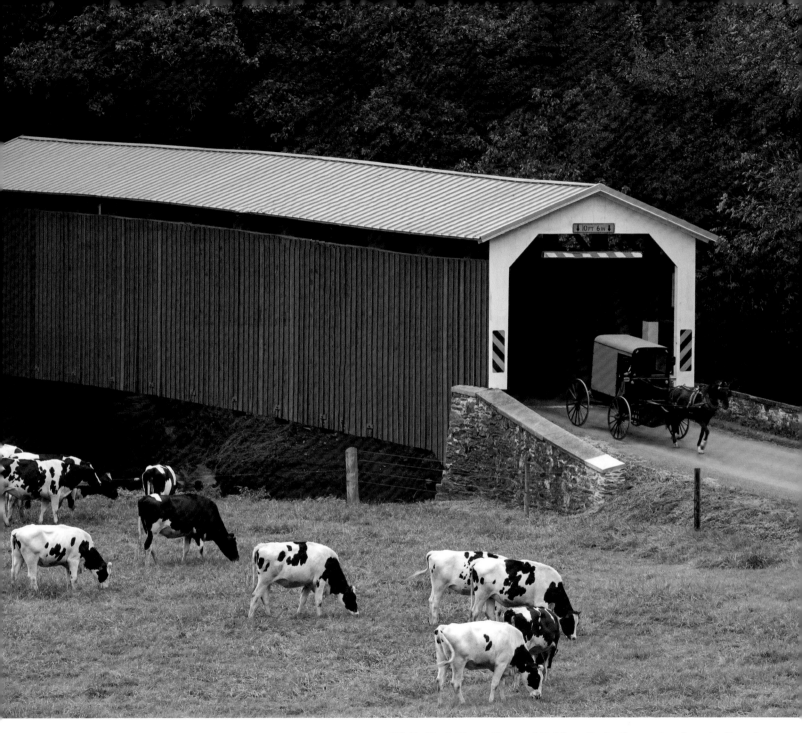

White Rock Forge Covered Bridge sits in the pastoral agricultural countryside of Lancaster County. The original bridge was built in 1847 but was destroyed and rebuilt in 1884. The 103-foot-long bridge spans the West Branch of the Octoraro Creek and was added to the National Register of Historic Places in 1980.

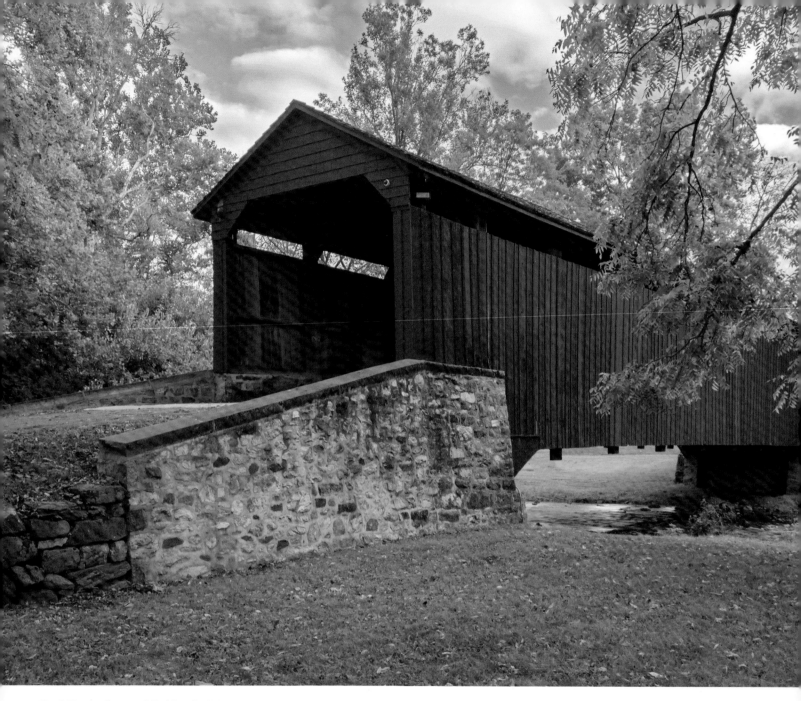

Pool Forge Covered Bridge in Lancaster County was constructed in 1859 for $1,219.00 after sixty-two citizens signed a petition requesting that Lancaster County build a bridge over the Conestoga River. It was added to the National Register of Historic Places in 1980.

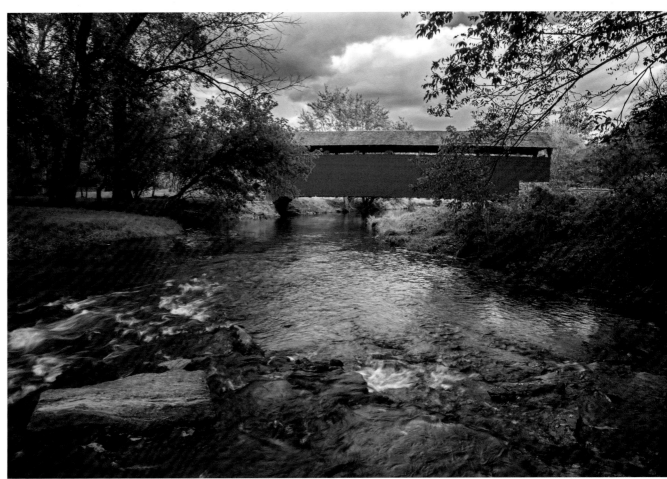

Speakman No.1 Covered Bridge was constructed in 1881 to serve Jonathan Speakman's gristmill in Chester County. The original cost of construction was $2,000.00. The 75-foot-long bridge spans Buck Run and was added to the National Register of Historic Places in 1980. Its twin, Speakman No.2 Covered Bridge, is 1.5 miles away.

Weaver's Mill / Isaac Shearer's Mill Covered Bridge in Lancaster County's Amish farmland spans Conestoga River. The 85-foot-long bridge was constructed in 1878 at a cost of $1,468.00. The bridge was added to the National Register of Historic Places in 1980.

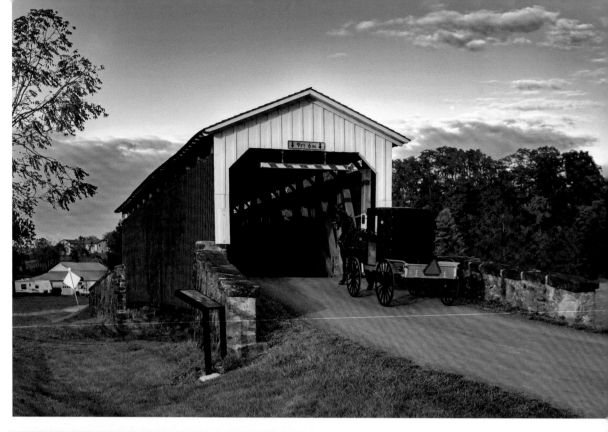

The Erb's / Hammer #1 Covered Bridge in Lancaster County was built in 1887 at a cost of $1,744.00 to connect the villages of Rothsville and Lincoln. It was named for the Erb family, large landowners in the area. The 80-foot-long bridge spans Hammer Creek.

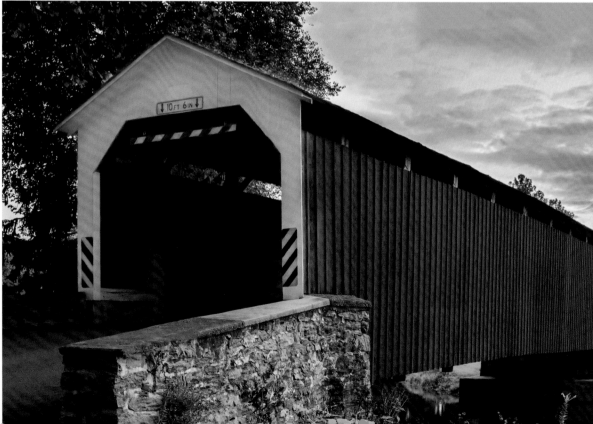

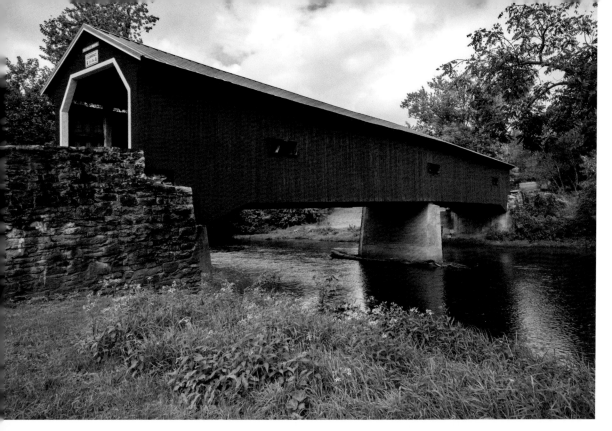

The 174-foot-long Dellville Covered Bridge in Perry County was built in 1889 over Sherman Creek. In 2014 the bridge was significantly damaged by fire. Over the next few years, the bridge was repaired at a cost of $966,000.00. In 2019, two men, juveniles at the time, were charged with arson.

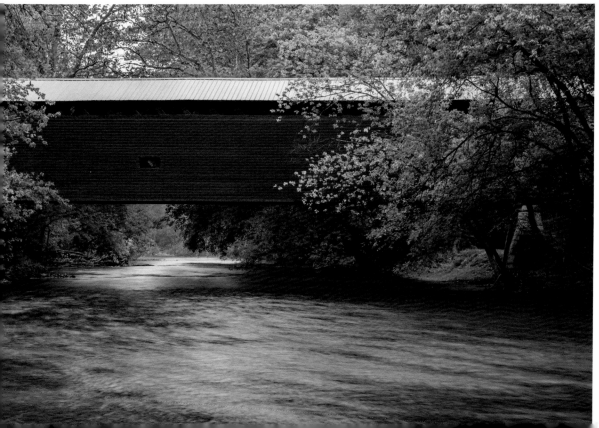

The 205-foot-long Martin's Mill / Martins Mill / Shindle Covered Bridge in Franklin County was built in 1849 over Conococheague Creek. Over the years it survived several near destructions, the last in 1991. It was scheduled to be demolished, but the Martin's Mill Covered Bridge Association stepped in to preserve the bridge, with final work restoration completed in 1995.

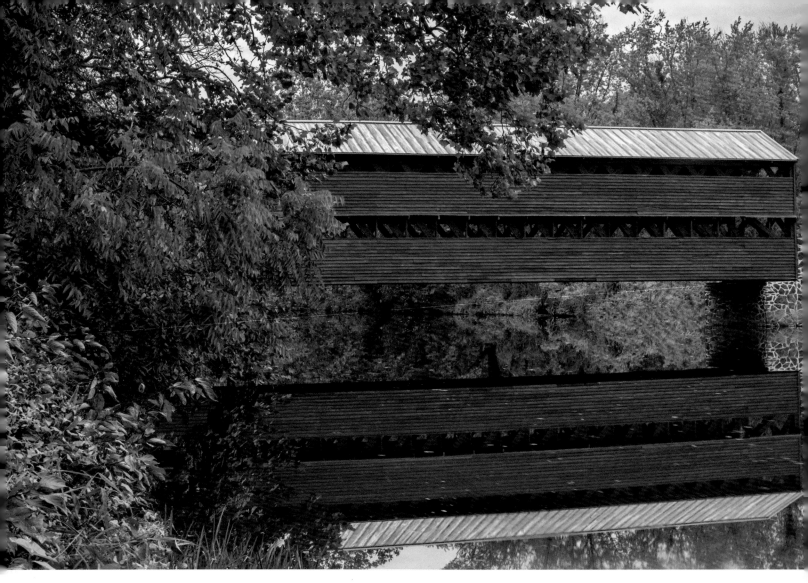

Sauck's/Sachs Covered Bridge near
Gettysburg National Military Park, Adams
County, was built in 1854 over Marsh
Creek. It is known that both Union and
Confederated armies used the bridge
during the 1863 Battle of Gettysburg. The
bridge was designated Pennsylvania's
"most historic bridge" in 1938. It is closed
to vehicles.

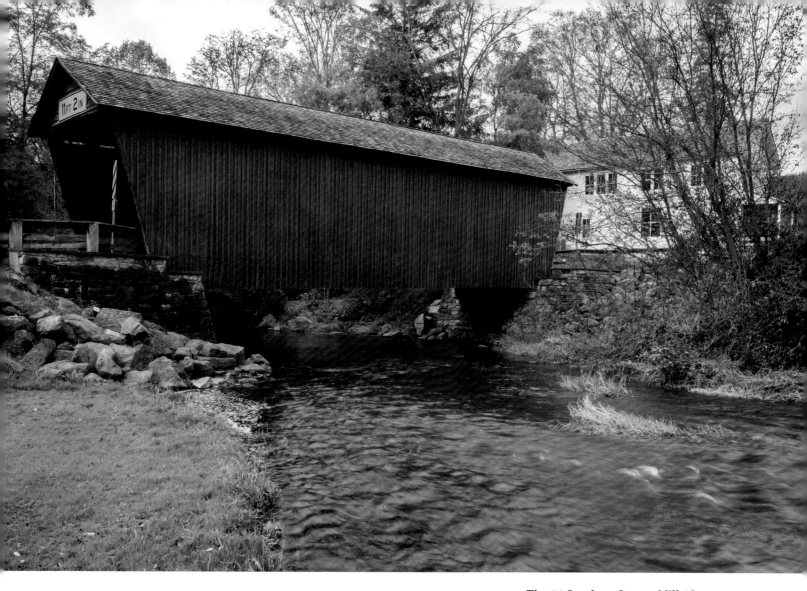

The 64-foot-long Logan Mill / Logan Mills Covered Bridge over Fishing Creek in Clinton County is the last surviving covered bridge in the county. Built in 1874, it is named for the nearby gristmill. Between 2002 and 2003 the bridge was reconstructed at a cost of $986,000.00.

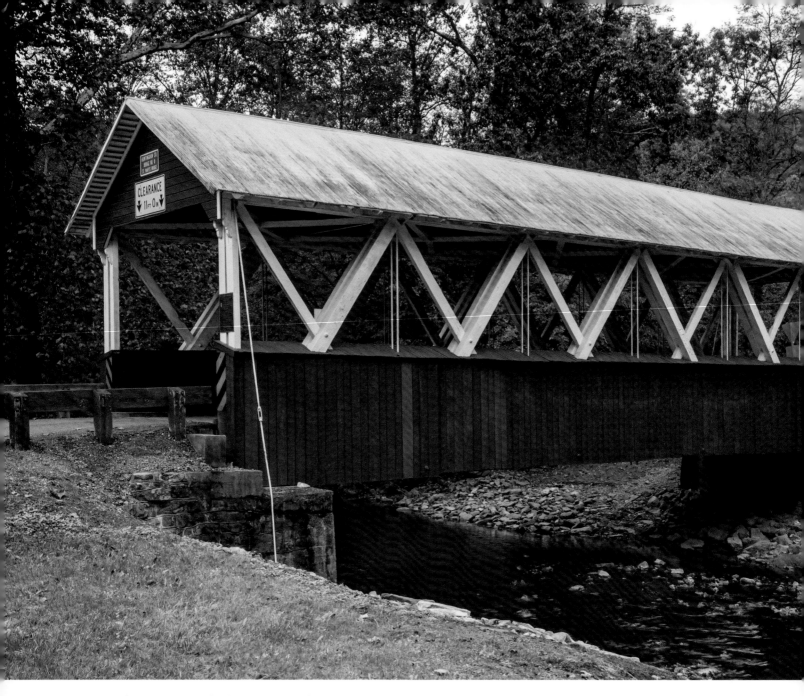

Saint Mary's / Saint Marys / Shade Gap Covered Bridge is the last surviving covered bridge in Huntingdon County. The location across the road from St. Mary's Roman Catholic Church makes for a picturesque setting. It was added to the National Register of Historic Places in 1980.

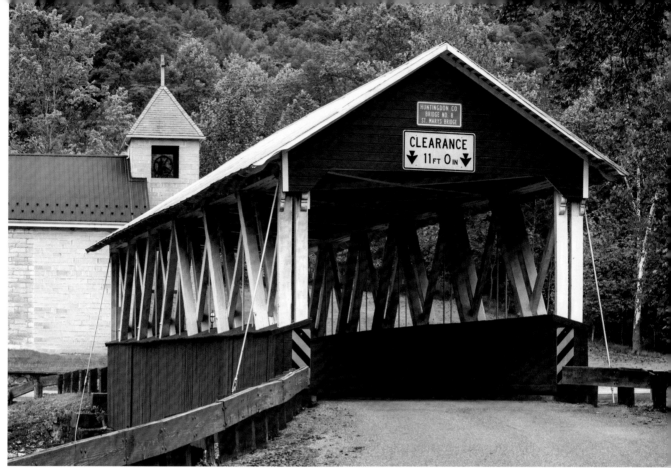

The 65-foot-long Saint Mary's / Saint Marys / Shade Gap Covered Bridge in Huntingdon County spans Shade Creek. Although the bridge generally is believed to have been built in 1889, other county research indicates it might have been built in 1896 by E. O. Rodgers for the sum of $540.00.

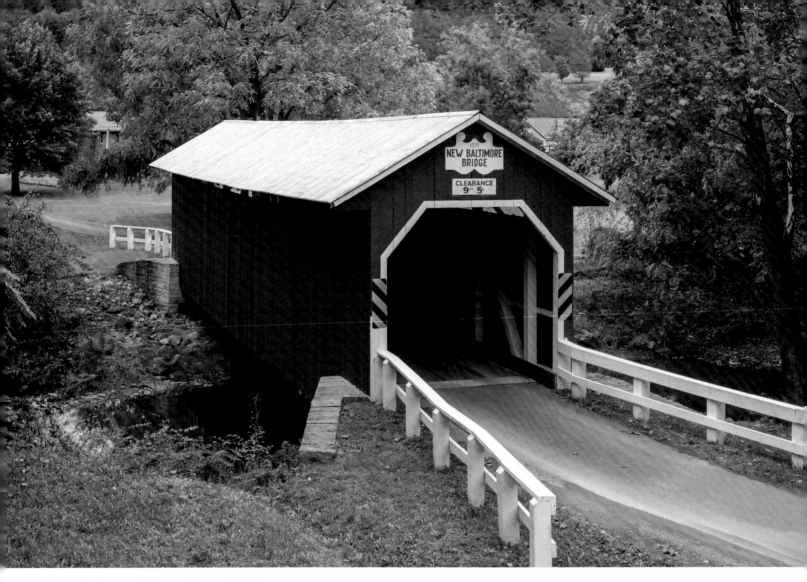

Beautiful New Baltimore Covered Bridge in Somerset County is a modern replica replacing the original 1879 bridge, which was destroyed by a 1996 flood. The 86-foot span crosses the Raystown Branch of Juniata River and is supported with steel I beams to handle modern traffic.

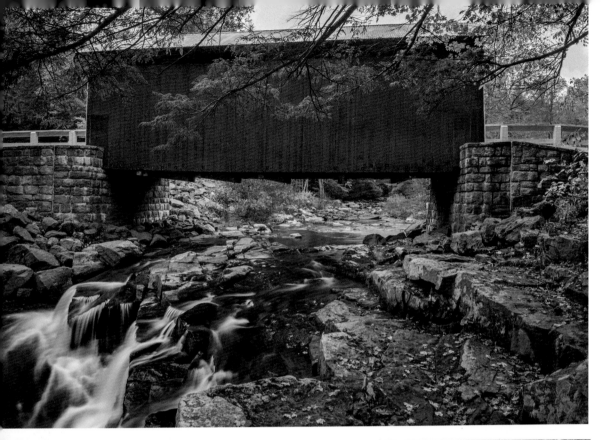

Packsaddle / Doc Miler / Doc Miller Covered Bridge in Somerset is the only covered bridge in Pennsylvania built over a waterfall. The 48-foot span crosses Brush Creek. Originally constructed in 1870, it survived several floods and was "sensitively" restored in 1998. It was added to the National Register of Historic Places in 1980.

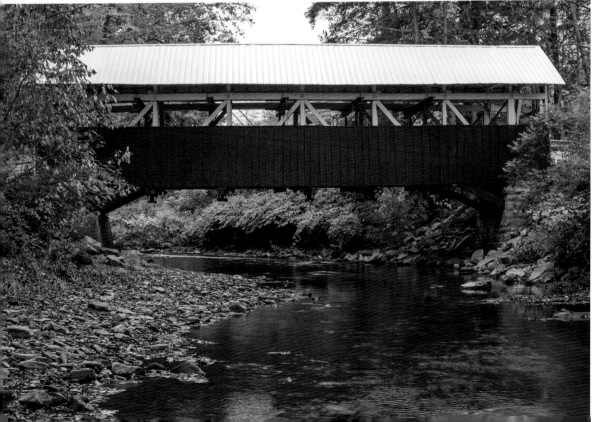

Shaffer / Ben's Creek Covered Bridge in Somerset County was constructed 1877 and has gone through few changes since it was built. Its 68-foot length spans Ben's Creek in a beautiful wooded setting. It was added to the National Register of Historic Places in 1980.

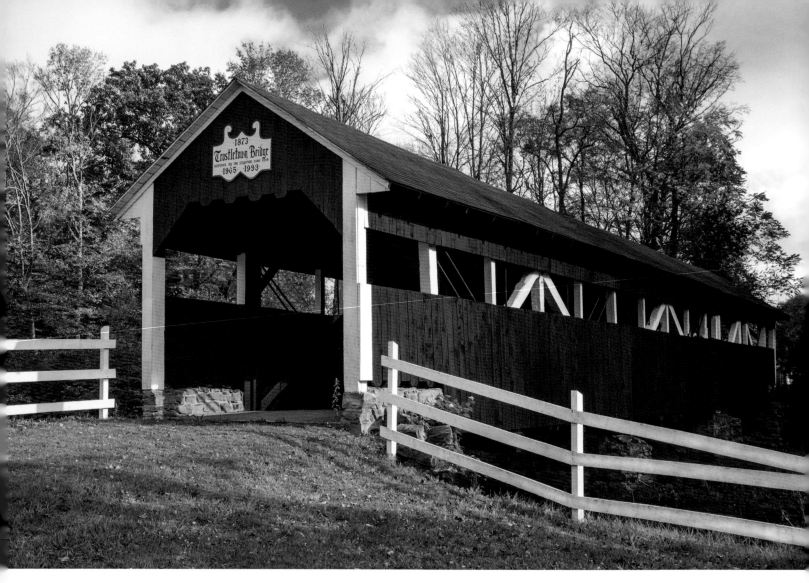

Trostletown/Kantner Covered Bridge in Somerset County is listed as being built in 1845. In 1965 the Stoystown Lions Club undertook the painstaking restoration of the deteriorating bridge and continues maintaining this beautiful bridge. The 104-foot-long span crosses Stony Creek and was added to the National Register of Historic Places in 1980.

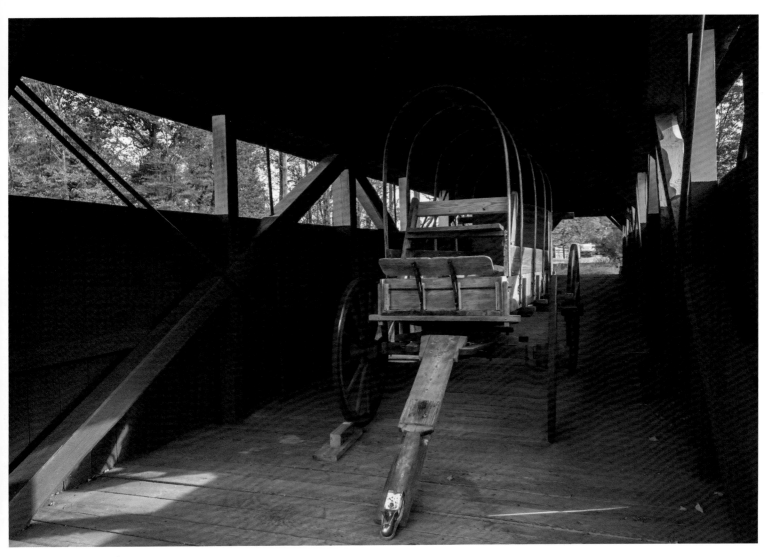

Visitors to the pedestrian-only Trostletown/Kantner Covered Bridge in Somerset County will also be rewarded in seeing an original Conestoga wagon donated in 2010 to the Stoystown Area Historical Society by Charles Miller, Kathryn Gallo, Susan Buchanan, and Lynn Barnhart.

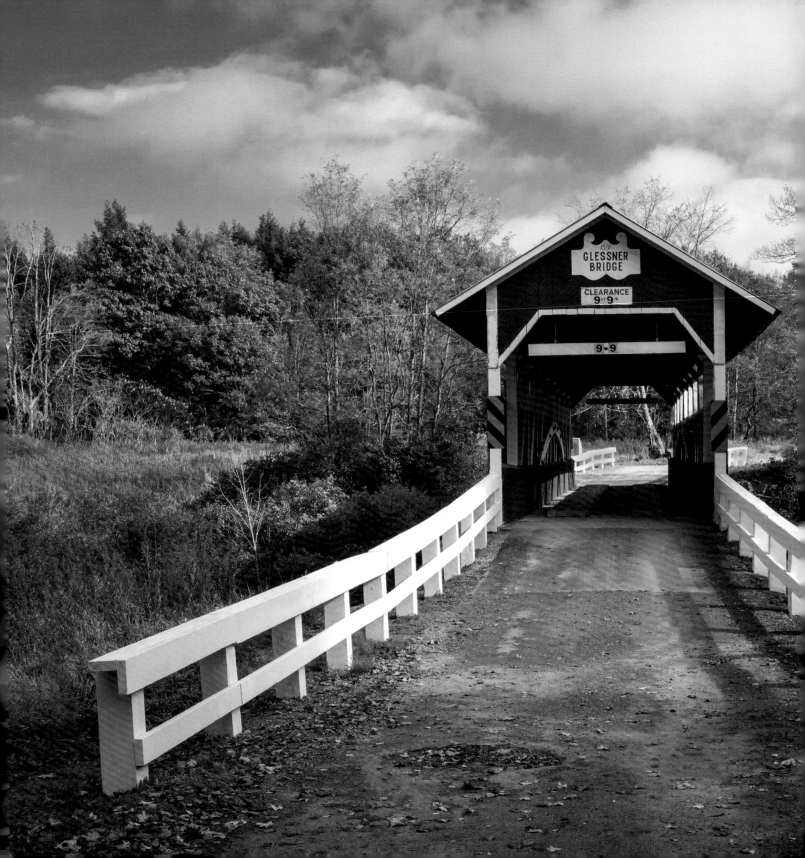

The 90-foot-long Glessner Covered Bridge in Somerset County was constructed over Stony Creek in 1881 at a cost of $412.00. It was named after its builder, Tobias Glessner. In 1998 it underwent a major rehabilitation and stands in testimony today of the beauty covered bridges bring to the countryside.

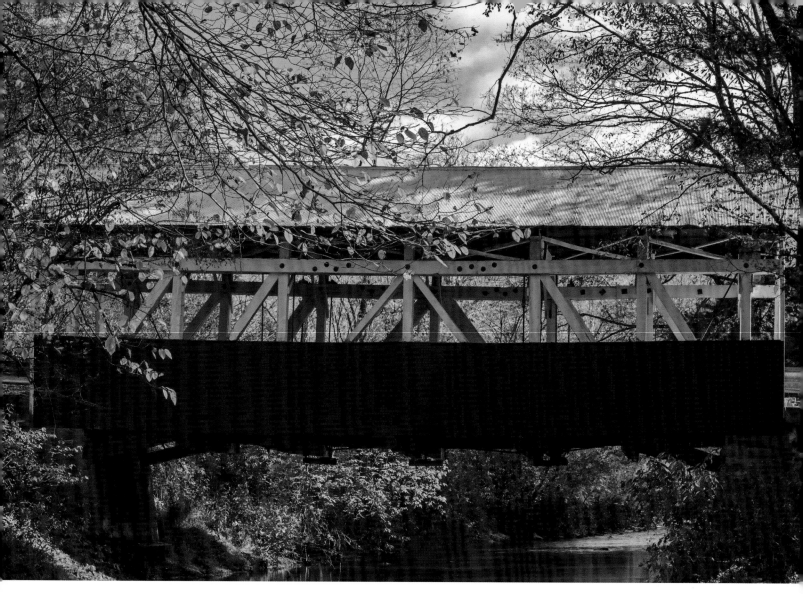

The Burkholder/Beechdale Covered Bridge spans Buffalo Creek in Somerset County. The 52-foot-long bridge was built in 1870, and in the twentieth century, steel stringers and beams were added to strengthen the structure. It was added to the National Register of Historic Places in 1980.

84

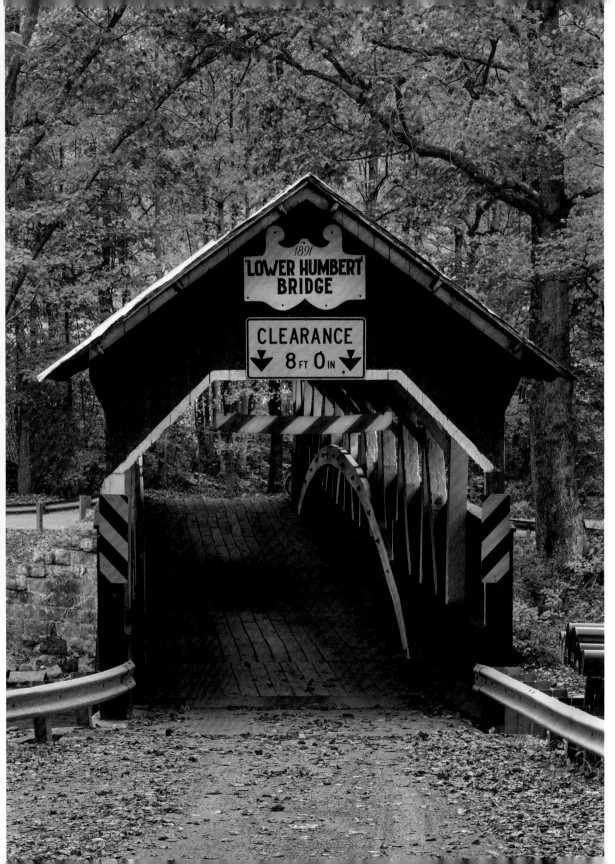

Picturesque from all angles, 126-foot-long Lower Humbert / Faidley Covered Bridge in Somerset County spans Laurel Hill Creek, a popular fishing stream. Built in 1891, it went through an extensive historically sensitive rehabilitation in 1991. In January 2006, vandals attempted to destroy the bridge with a crude homemade bomb.

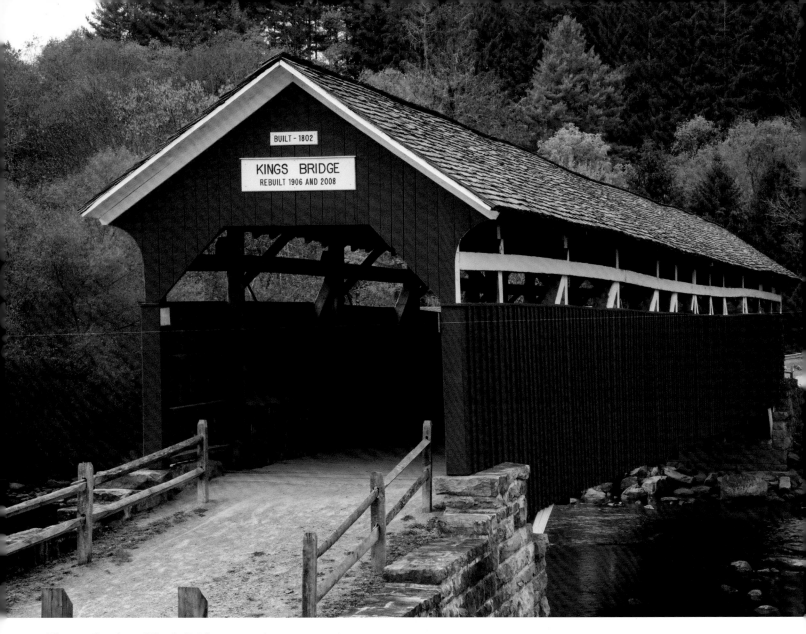

The 127-foot-long King's Bridge, spanning
Laurel Hill Creek in Somerset County,
went through a historically sensitive
rehabilitation in 2005. Built sometime in
the mid-nineteenth century, it was rebuilt
in 1906. In its history it once served as a
livestock barn. A small community park
is located next to this beautiful bridge.

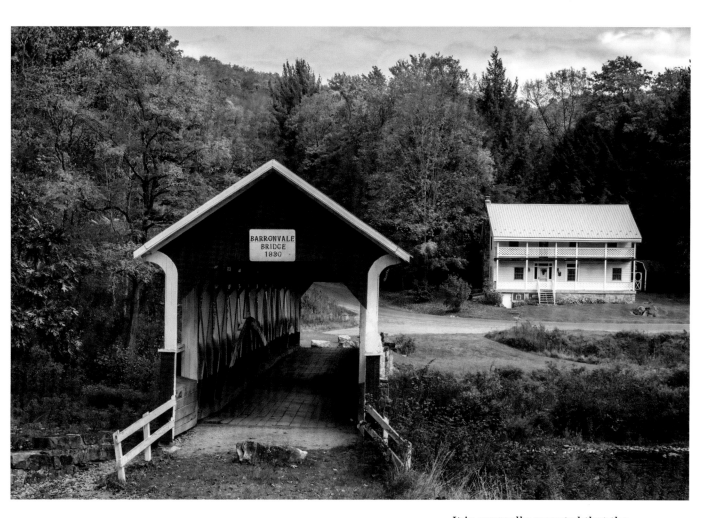

It is generally accepted that the Barronvale Covered Bridge in Somerset County was built in 1902, although some sources date it back to 1830 and 1846. Regardless of the actual date, it remains as one of the most beautiful covered bridges in Pennsylvania. It is open for pedestrian travel only.

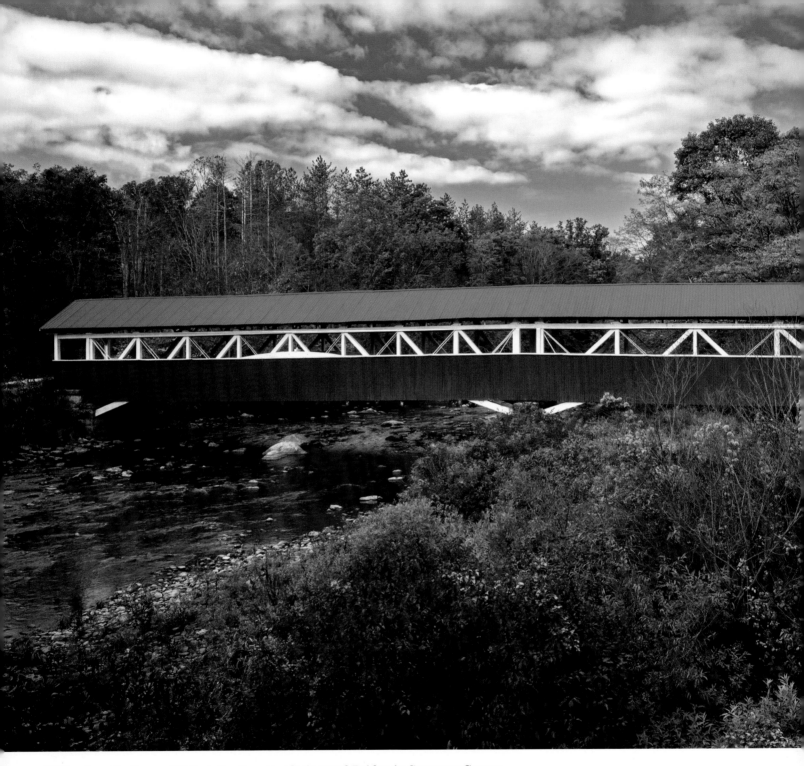

With a length of over 162 feet, the Barronvale Covered Bridge in Somerset County is the longest covered bridge in the county. It spans Laurel Hill Creek. It was added to the National Register of Historic Places in 1980.

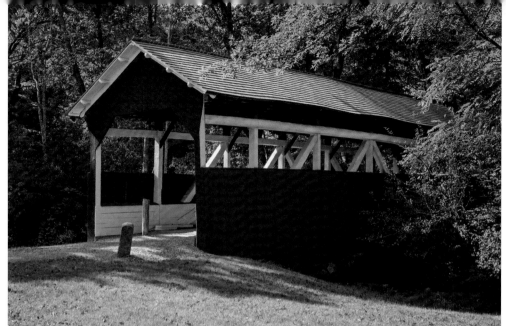

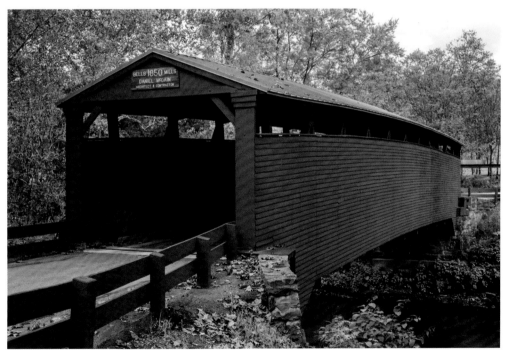

[Top] Mill/Cox Creek Covered Bridge, after being threatened with destruction in the early 1960s, was relocated to the grounds of the Somerset Historical Center and underwent restoration in 1986. It now spans Haupts Run and is open for pedestrian traffic.

[Bottom] Bells Mills / Bell's Mills Covered Bridge is the last remaining covered bridge in Westmoreland County. The 95-foot-long bridge was built in 1850 over Sewickley Creek and named for the nearby Bell brothers gristmill. The bridge design features unusual Greek Revival portal support posts and gable ends.

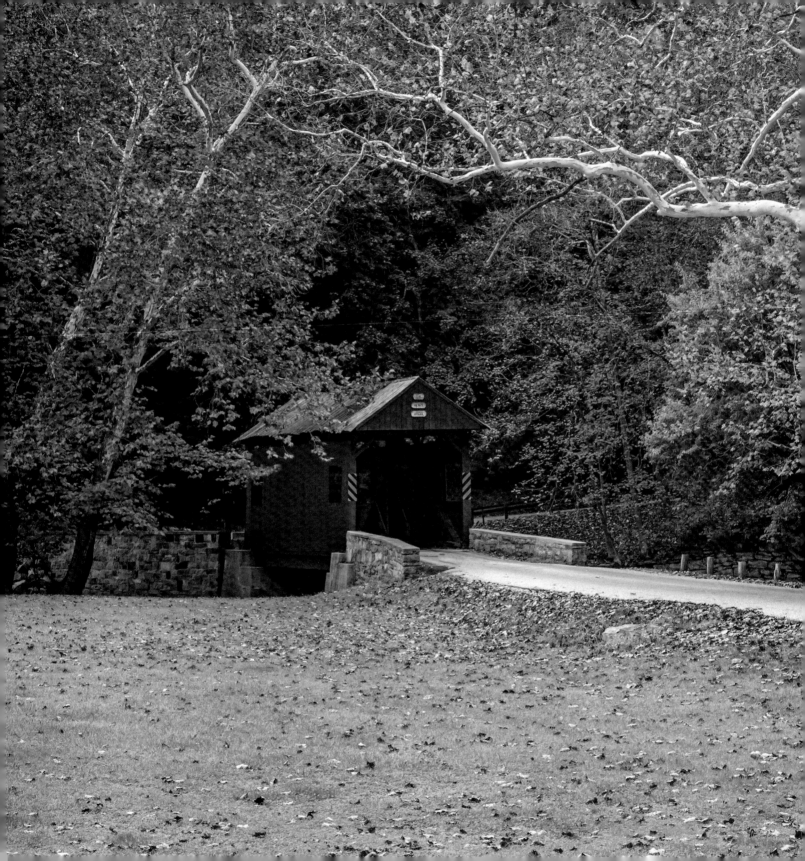

The 36-foot-long Henry Covered Bridge in Washington County was built in 1881 over Mingo Creek in what is now Mingo Creek County Park. The large American sycamore tree growing to the right of the bridge is a common species found near covered bridges, since it prefers to grow along streamsides.

It is unknown exactly
when Ebenezer
/ Ebenezer Church
Covered Bridge in
Washington County
was built. Originally it
crossed the South Fork
of Maple Creek. In 1977
it was moved to span
Mingo Creek in Mingo
Creek County Park. The
park is the site of the
annual Washington &
Greene Counties Covered
Bridge Festival.

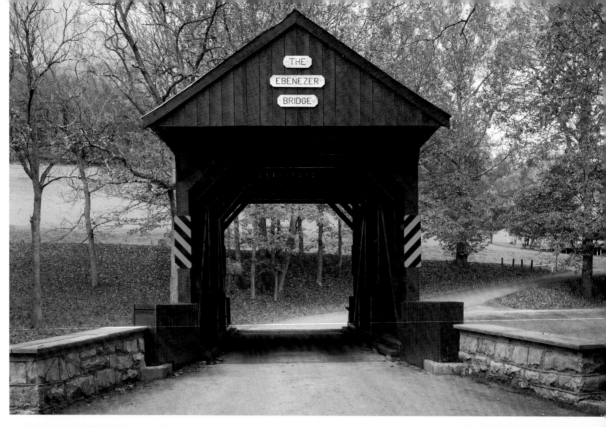

Wright/Cerl Covered
Bridge in Washington
County spans the North
Branch of Pigeon
Creek. The 13-foot-long
bridge was built in 1875
and restored in 1999.
It is easily seen from
Interstate 70, sitting in
open farmland near the
Kammerer exit. Motorists
speeding by are
reminded of a simpler
time in America.

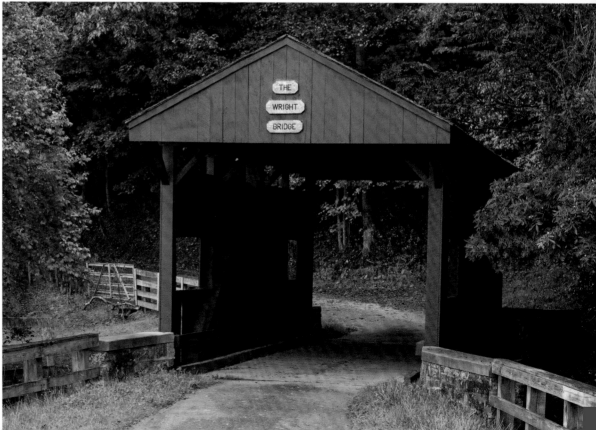

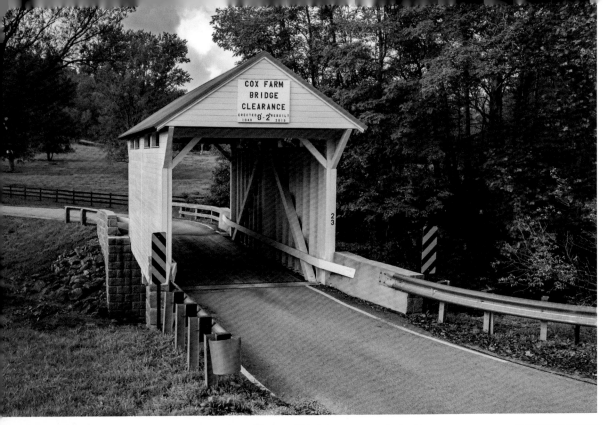

With a length of only 31 feet, beautiful Cox Farm / Lippincott Covered Bridge is not only the shortest covered bridge in Greene County but also the newest. It was built to span Ruff Creek in 1943 during World War II, and due to the shortage of steel it was constructed of lumber.

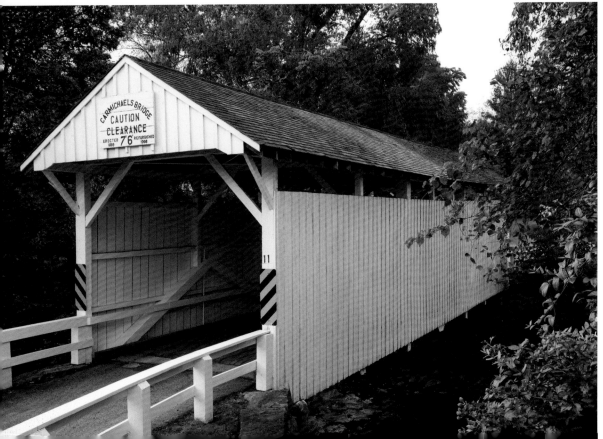

The 64-foot-long Carmichaels Covered Bridge in Greene County was built in 1889 over Muddy Creek. It was rehabilitated in 1998 and is the site of the annual Covered Bridge Festival. It was added to the National Register of Historic Places in 1979.

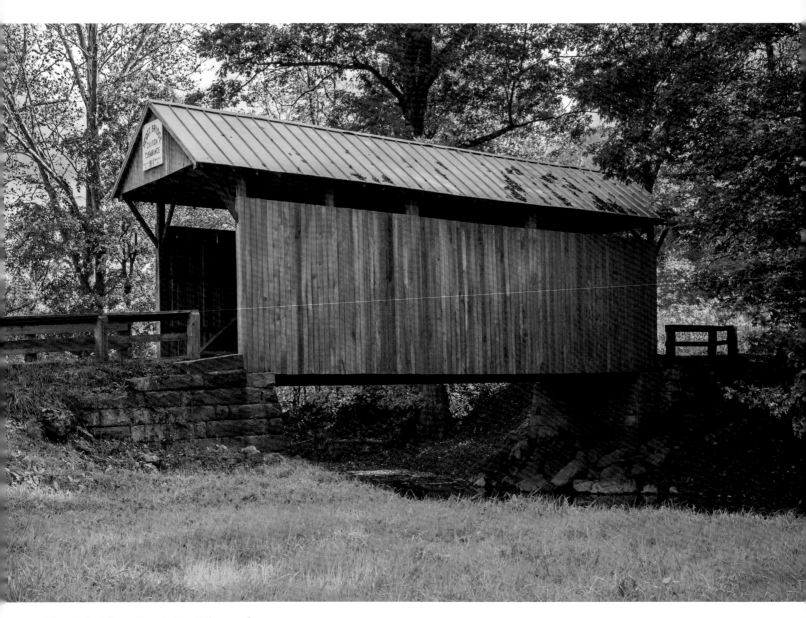

The 41-foot-long Scenic Scott Covered
Bridge in Greene County was built in
1885 to span Ten Mile Creek. The natural
unpainted bridge was rebuilt in 2008
and reinforced with I beams. It is open
to vehicle and pedestrian traffic. It was
added to the National Register of Historic
Places in 1979.

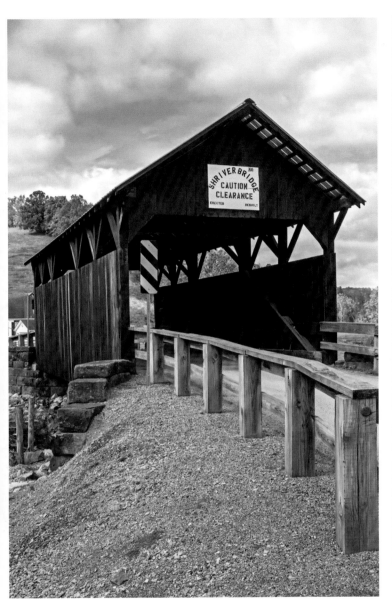

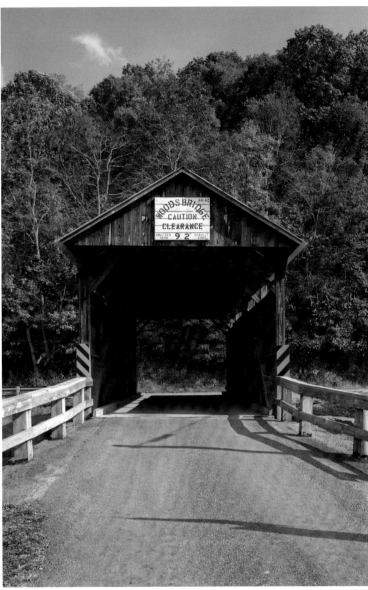

Shriver Covered Bridge is located in the beautiful farmland of Greene County. Built in 1900, the 45-foot-long bridge spans Hargus Creek. It was reconstructed in 2013, after being added to the National Register of Historic Places in 1979.

Built in 1882, Neddie Woods / Nettie Woods Covered Bridge is the oldest covered bridge in Greene County. It was named for Edward (Ned or Neddie) W. Wood, a Civil War veteran and local landowner. The 43-foot-long bridge spans Pursley Creek. It was added to the National Register of Historic Places in 1979.

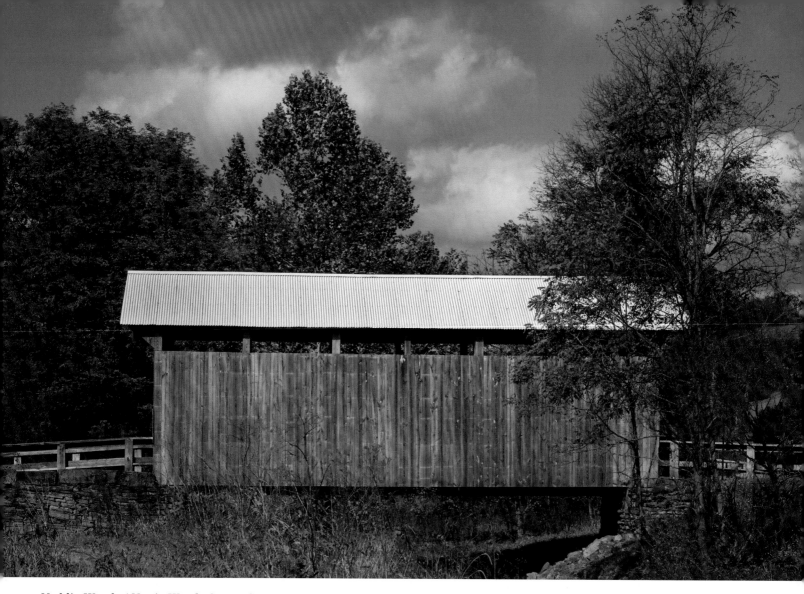

Neddie Woods / Nettie Woods Covered Bridge in Greene County was rehabilitated in 2005 and reinforced with six steel I beams to handle modern traffic. It is located in the open farmland and remains unpainted to weather naturally.

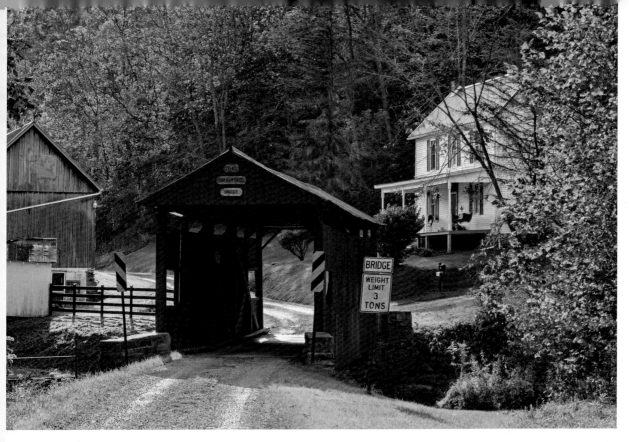

Historic Crawford Covered Bridge rests in the pastoral farmland of Washington County. Like with some other bridges in the county, the actual date of construction is unknown. The 39-foot-long bridge spans Robinson Fork, Wheeling Creek. It was added to the National Register of Historic Places in 1979.

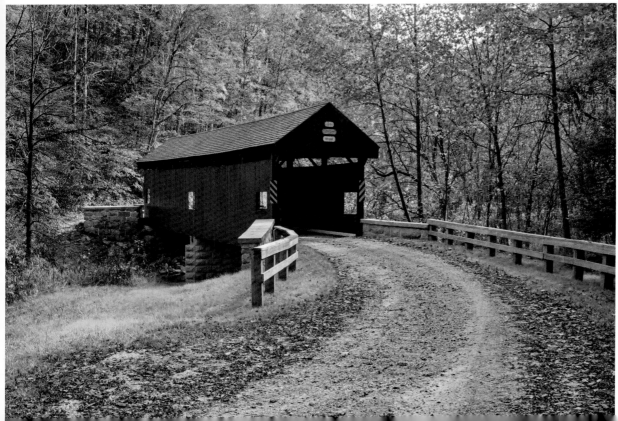

The actual date when the Longdon L. Miller / Longdon Covered Bridge was built in Washington County is unknown. At over 67 feet long, it is the longest covered bridge in the county. It spans Templeton Fork of Wheeling Creek in a beautiful forested area. It was restored in 2001.

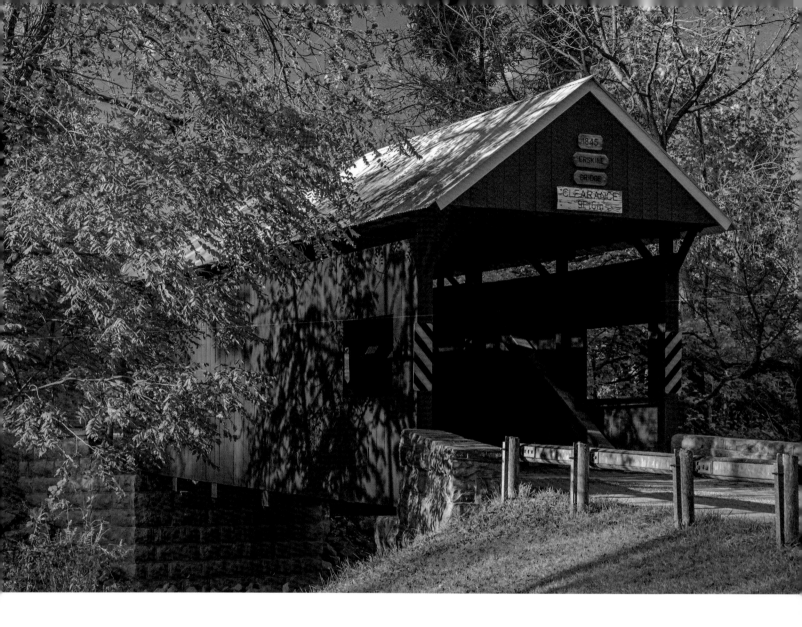

Built in 1845, Erskine Covered Bridge is the
oldest in Washington County. In addition,
it is the most westerly covered bridge in
Pennsylvania, located one-tenth of a mile
from the West Virginia border. The 39-foot-
long bridge spans the Middle Wheeling
Creek and is named for the Erskine family,
nineteenth-century landowners.

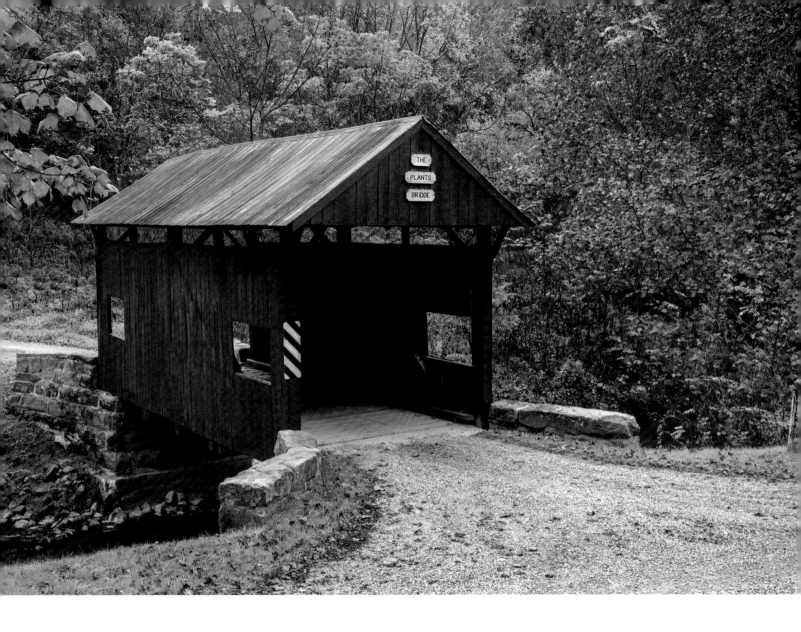

Plants Covered Bridge in Washington County is believed to have been built in 1876. The 24-foot-long bridge spans Templeton Fork of Wheeling Creek. It is named after a local carpenter and successful farmer, Leonard Plants.

The 27-foot-long Sprowl's Covered Bridge in Washington County spans Rocky Run. It was built in 1875 in a remote rural valley along an earthen road. In 2000 it was damaged by nearby mining, and restorations were made that year. It was added to the National Register of Historic Places 1979.

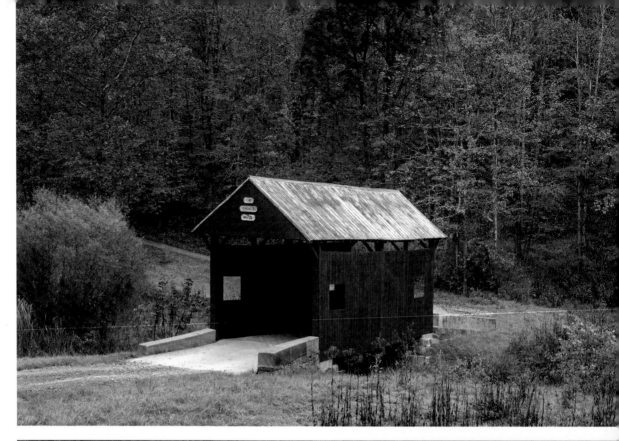

Built in 1915 along Robinson Fork of Wheeling Creek in Washington County, Wyit Sprowls Covered Bridge was moved to its current location, East Finley Township Park, in 2000 to save it from destruction. Now sitting next to the Jordan One-Room Schoolhouse makes it one of the most attractive scenes in Pennsylvania.

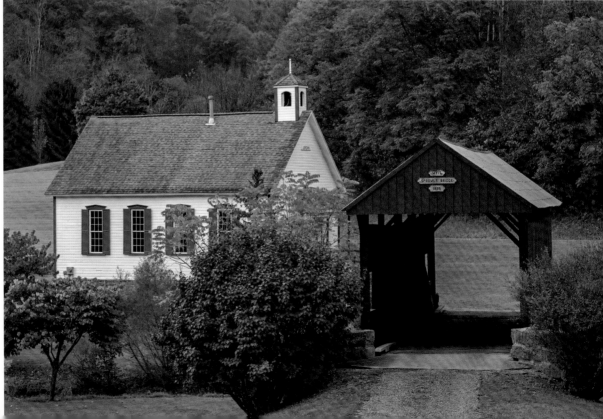

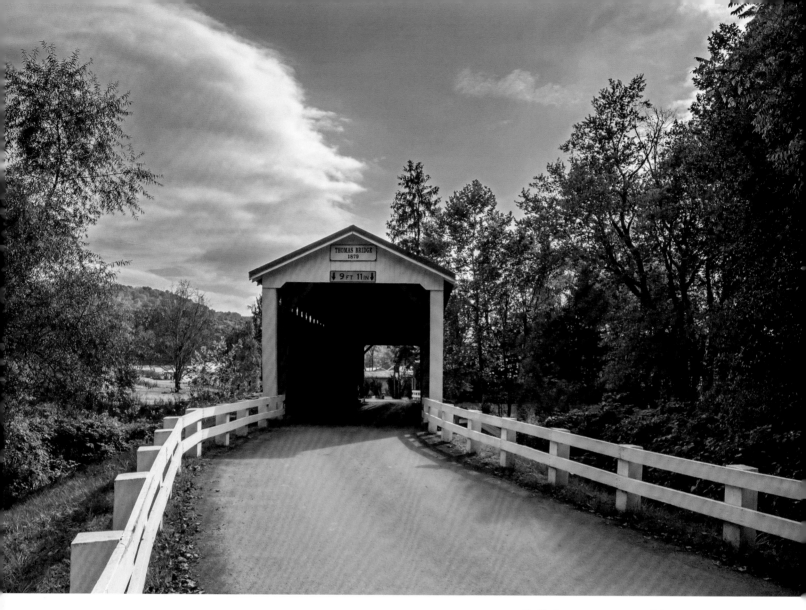

Built in 1879 at a cost of $545.00 over
Crooked Creek in Indiana County,
Thomas / Thomas Ford Covered Bridge is
the longest covered bridge in the county,
at 85 feet. The bridge was completely
reconstructed in 1998 at a reported cost of
slightly over one million dollars.

Built in 1910 for $525.00, Harmon's Covered Bridge in Indiana County is the newest of the four remaining bridges in the county, yet it sits in probably one of the most scenic locations. Its 45-foot length spans South Branch Plum Creek, and it was named for Civil War veteran J. S. Harmon.

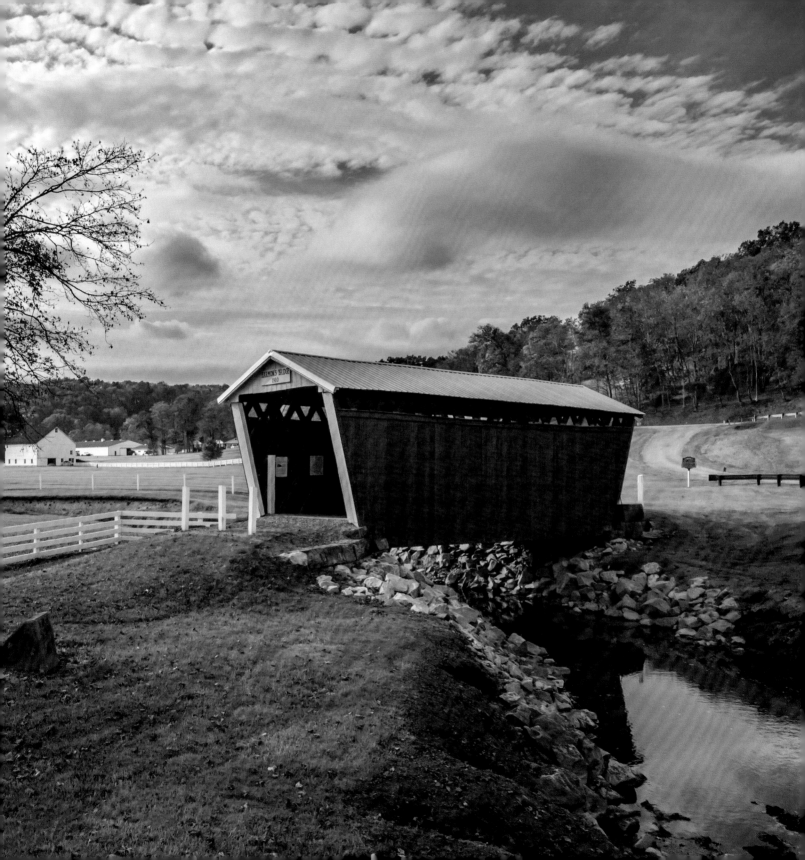

The Kintersburg
Covered Bridge in
Indiana County is one of
four remaining bridges
in Pennsylvania with
a Howe truss. It was
built in 1877 for $893.00
to span Crooked Creek
but was bypassed by a
modern bridge in 1974.
It's named in honor of
local Revolutionary War
veteran John Kinter.

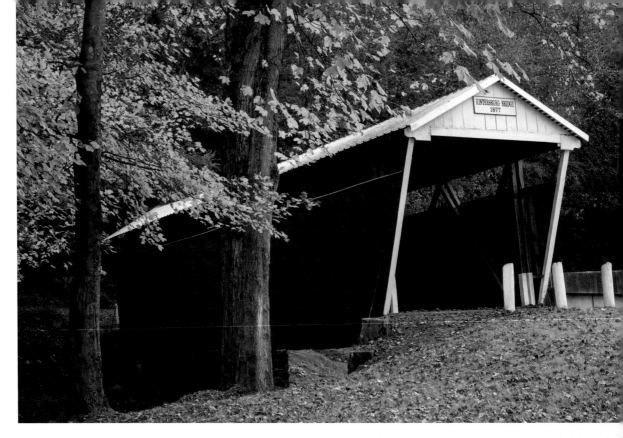

Colemanville / Martic
Forge Covered Bridge in
Lancaster County was
originally built in 1856
over Pequea Creek for
a reported $2,244.00.
Being damaged by
flooding, it was rebuilt
several times until 1992,
when it was completely
rebuilt for $350,000.00,
raised 6 feet, and moved
a few feet to protect it
from future floods.

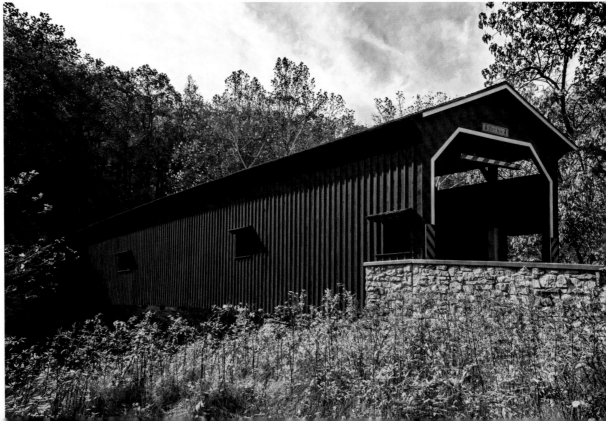

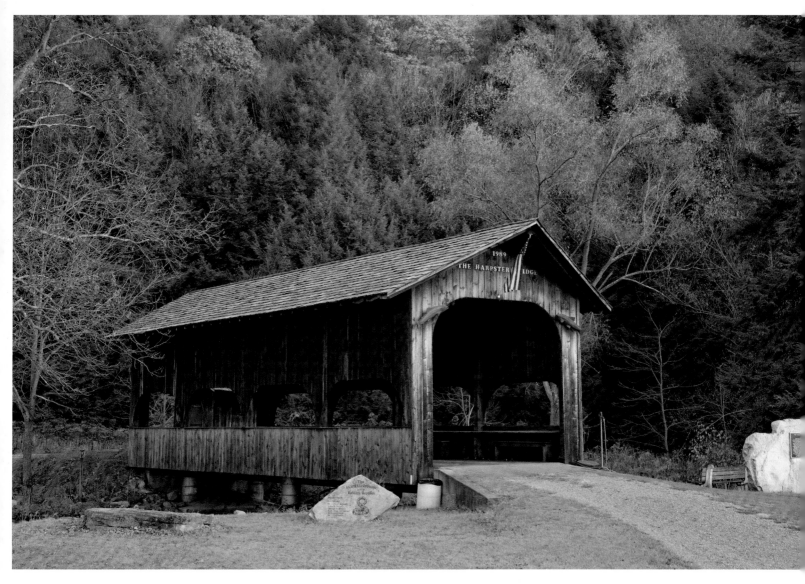

Although not a typical historical covered bridge, Harpster Bridge, spanning Spruce Creek in Huntington County, has a unique place in American history. Wayne Harpster was a fishing buddy with President Jimmy Carter. When he was building the bridge in 1989, President Carter and his wife, Rosalynn, helped with the construction.

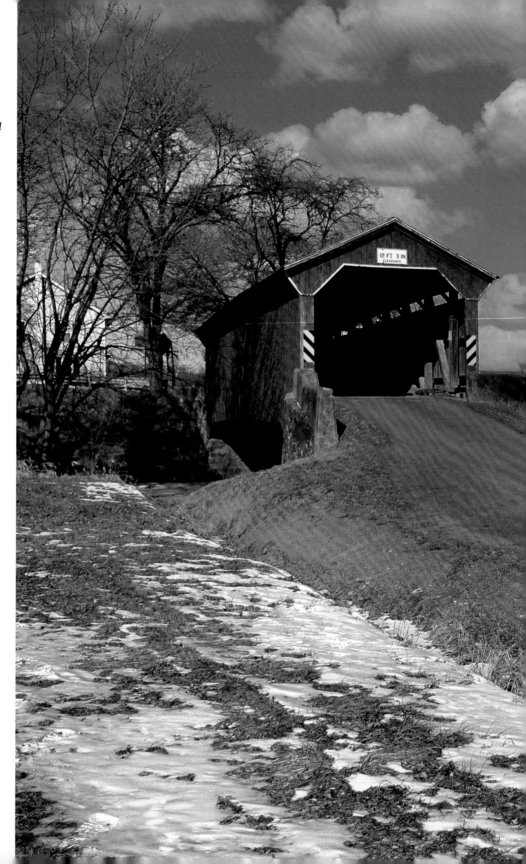

Gottlieb Brown / Gottlieb / Sam Wagner Covered Bridge spans Chillisquaque Creek on the border of Montour and Northumberland Counties in scenic farm country. The 86-foot-long bridge was built in 1881 for $939.99 and was named for the nearby Gottlieb Brown Farm. It was added to the National Register of Historic Places in 1979.

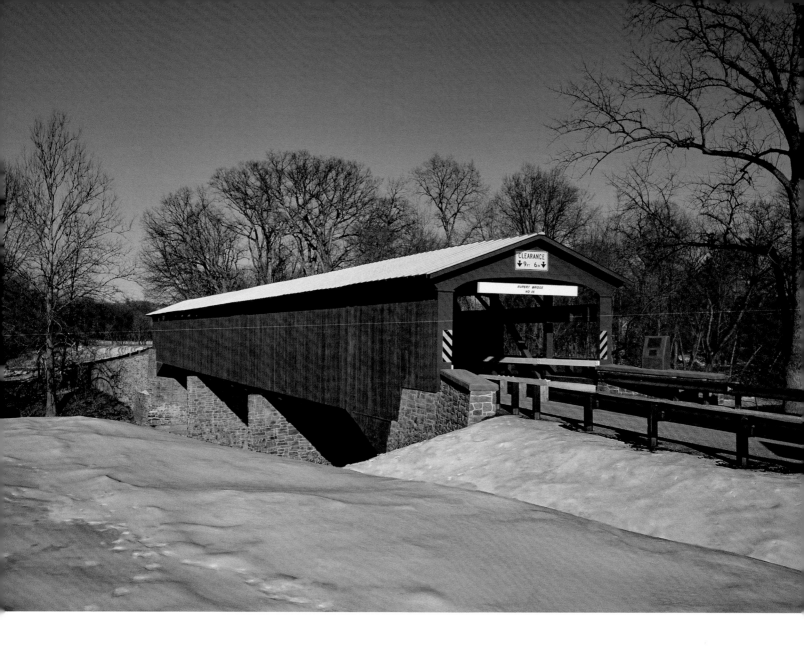

Originally built in 1847 over Fishing Creek
in Columbia County, Rupert Covered
Bridge was beautifully renovated in 2001.
It's the oldest existing covered bridge
in the county. The bridge is named for
Leonard Rupert, a 1788 area settler. It was
added to the National Register of Historic
Places in 1979.

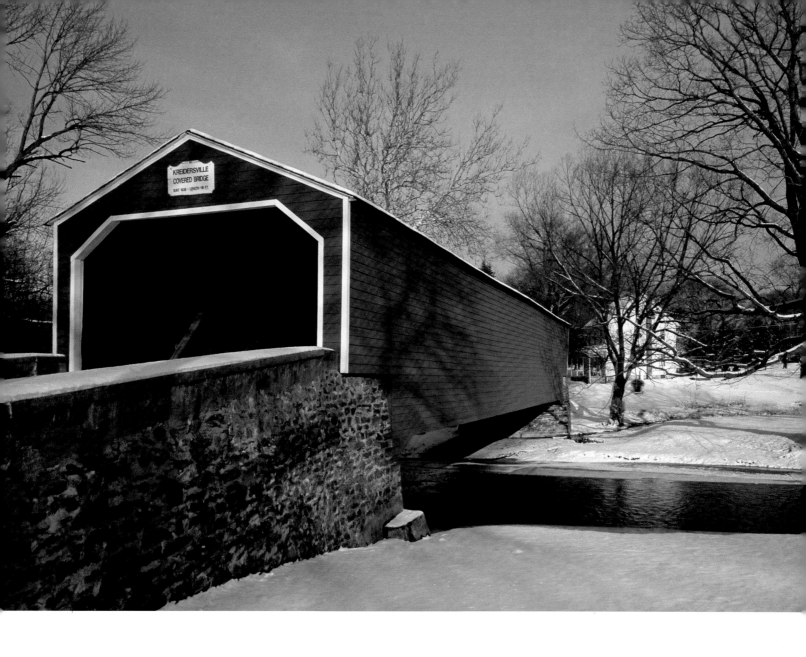

The 96-foot-long Historic Kreidersville Covered Bridge was built over Hokendauqua Creek in 1839. It is the last remaining covered bridge in Northampton County and one of the oldest in the state. In 1959, when the state planned to demolish the bridge, a group of motivated citizens rallied for its preservation.

Several covered bridges in what is known as Pennsylvania Dutch country display hex signs, as seen here on Dreibelbis Station Covered Bridge, Berks County. These hex signs are particularly common on barns. They have German origins, and some believe they are to ward off evil, while others see them as just decorative.

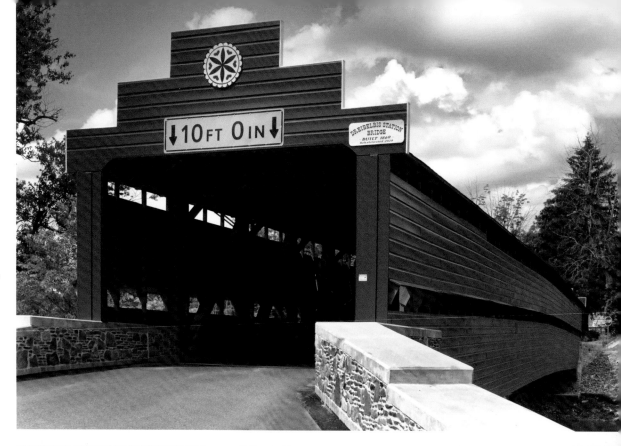

Dreibelbis Station Covered Bridge, Berks County, was built in 1869 over Maiden Creek. It was named for Manassas Dreibelbis, landowner and petitioner for the bridge. In 1874, when the Schuylkill and Lehigh Railroad came to the area, it became known as Dreibelbis Station. The bridge underwent major restoration in 2020.

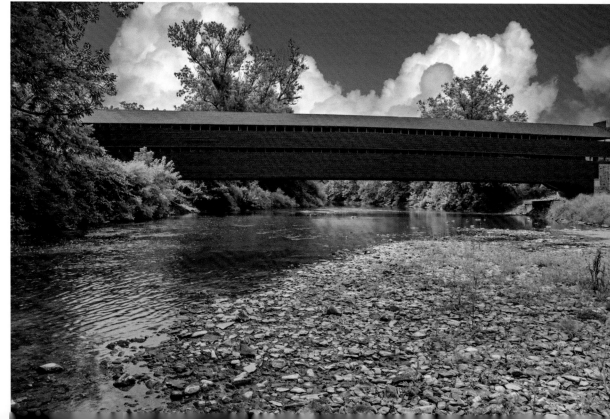

About the Author

Michael P. Gadomski is a third-generation Pennsylvania native. He worked as a Pennsylvania state park ranger and naturalist for more than 25 years and has been a freelance writer and photographer for more than 40 years. His articles have appeared in publications such as the *New York State Conservationist* and *Highlights for Children*. His photography has been published worldwide in books, calendars, interpretive displays, and magazines. He is the photographer/writer of nine coffee-table books: *Wild Pennsylvania: A Celebration of Our State's Natural Beauty, Philadelphia: Portrait of a City, The Catskills: A Photographic Portrait, Reserves of Strength: Pennsylvania's Natural Landscape, Pittsburgh: A Renaissance City, The Poconos: Pennsylvania's Mountain Treasure, Pennsylvania: A Portrait of the Keystone State, Scenes from the Country Fair,* and *Delaware Water Gap National Recreation Area.*

His website is www.mpgadomski.com.

Bibliography

Books

Biehler, Allen D. (secretary of transportation). *Covered Bridges of Pennsylvania*. Harrisburg, PA: PENNDOT Tourism Services Division, 2005.

Evans, Benjamin D., and June R. Evans. *Pennsylvania's Covered Bridges: A Complete Guide*. Pittsburgh, PA: University of Pittsburgh Press, 1993 (later editions available).

Fredericks, Anthony D. *Lancaster & Lancaster County: A Traveler's Guide to Pennsylvania Dutch County*. Woodstock, VT: Countryman, 2014.

Sloane, Eric. *Eric Sloane's America*. New York: Promontory, 1992.

Stiver, Harold. *Covered Bridges of Pennsylvania: A Sourcebook for Photographers and Explorers*. Canada: Harold Stiver, 2014.

Walczak, Thomas E. *Covered Bridges: A Close-Up Look*. East Petersburg, PA: Fox Chapel, 2011.

Waters, Bruce M. *Bridges of Lancaster County*. Atglen, PA: Schiffer, 2010.

Zacher, Susan M. *The Covered Bridges of Pennsylvania: A Guide*. Harrisburg: Commonwealth of Pennsylvania, Pennsylvania Historical and Museum Commission, 1994.

Maps

Pennsylvania Atlas and Gazetteer. Freeport, ME: Delorme Mapping, 2000.

Pamphlets

Covered Bridges of Bedford County, Pennsylvania. Bedford, PA: Bedford County Visitors Bureau.

Covered Bridges of Bucks County, Pennsylvania. Perkasie, PA: Bucks County Covered Bridge Society.

Covered Bridges of Columbia & Montour Counties Pennsylvania. Bloomsburg, PA: Columbia Montour Visitors Bureau.

Covered Bridges of Indiana County. Indiana, PA: Indiana County Parks & Trails.

Covered Bridges of the Susquehanna River Valley. Lewisburg, PA: Susquehanna River Valley Visitors Bureau.

Covered Bridge Tour: Greater Reading, Pennsylvania. Reading, PA. Pennsylvania's Americana Region Visitors Center.

Greene County Pennsylvania 2020 Official Visitors Guide. Waynesburg, PA: Greene County Tourist Promotion Agency.

Websites

Bucks County Covered Bridge Society. https://buckscountycbs.org

Columbia County PA Covered Bridges. http://www.columbiapa.org/coveredbridges/

Covered Bridges of Bedford County. https://www.visitbedfordcounty.com/coveredbridges/

Historic Bridges of Somerset County Pennsylvania. https://www.penndot.gov/ProjectAndPrograms/Cultural%20Resources/StoriesandHighlights/Documents/Historic%20Bridges%20of%20Somerset%20County_150%20higher%20resolution.pdf

Kreidersville Covered Bridge Association. https://kreidersvillecoveredbridge.org/history

Parks and Trail Indiana County. https://www.indianacountyparks.org/covered_bridges/default.aspx

The Covered Bridges of Somerset County. https://somersetcountychamber.com/wp-content/uploads/2017/08/covered-bridge-tour.pdf

The Theodore Burr Covered Bridge Society of Pennsylvania, Inc. http://www.tbcbspa.com/index.htm

"Trout Stream Owner Forged Bond with President Carter." https://old.post-gazette.com/sports/outdoors/20010610carter0610p6.asp

The Washington and Greene Counties' Covered Bridges Driving Tour. https://www.washcochamber.com/downloads/drive-book10-27.compressed.pdf

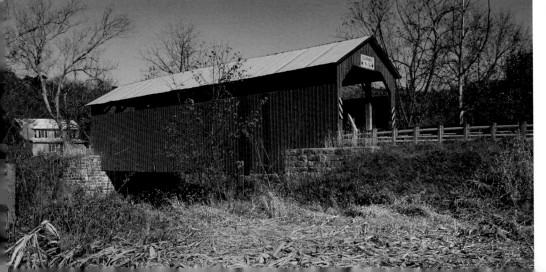

Sitting in scenic farmland, the 62-foot-long North Oriental / Oriental / Curry's Corner / Beaver Covered Bridge was built in 1908, spanning Mahantango Creek in Juniata and Snyder Counties. It was rebuilt in 1987 after being damaged by a truck. It was added to the National Register of Historic Places in 1979.